PAPIER-MÂCHÉ

A step-by-step guide to creating more than a dozen adorable projects!

SARAH HAND

Inspiring | Educating | Creating | Entertaining

Brimming with creative inspiration, how-to projects, and useful information to enrich your everyday life, Quarto Knows is a favorite destination for those pursuing their interests and passions. Visit our site and dig deeper with our books into your area of interest: Quarto Creates, Quarto Cooks, Quarto Homes, Quarto Lives, Quarto Drives, Quarto Explores, Quarto Gifts, or Quarto Kids.

© 2021 Quarto Publishing Group USA Inc.
Artwork and text © 2021 Sarah Hand

First published in 2021 by Walter Foster Publishing, an imprint of The Quarto Group.
26391 Crown Valley Parkway, Suite 220, Mission Viejo, CA 92691, USA.
T (949) 380-7510 F (949) 380-7575 **www.QuartoKnows.com**

Walter Foster Publishing titles are also available at discount for retail, wholesale, promotional, and bulk purchase. For details, contact the Special Sales Manager by email at specialsales@quarto.com or by mail at The Quarto Group, Attn: Special Sales Manager, 100 Cummings Center, Suite 265D, Beverly, MA 01915, USA.

ISBN: 978-1-63322-892-4

Digital edition published in 2021
eISBN: 978-1-63322-893-1

Printed in China
10 9 8 7 6 5 4 3 2 1

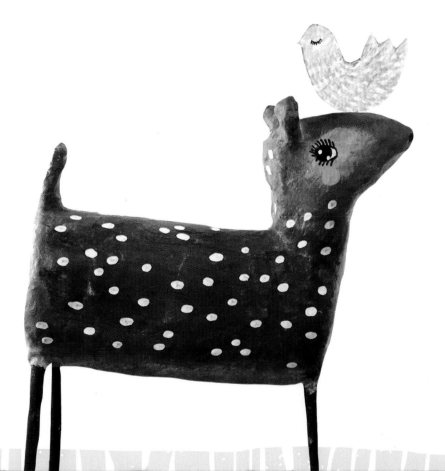

Table of Contents

Introduction

"I haven't done papier-mâché since elementary school!" say most of my adult students at the beginning of a new class.

It was the same for me. Papier-mâché and I became reacquainted when I was 30. I made a hilarious collaborative puppet show for my friends and created all of the puppets. I needed a very specific character, so I decided to papier-mâché it. It was poorly done; I used wire, which isn't my ideal sculpting material, and paper towel with a bumpy texture to create the papier-mâché. But there was something to it...something lumpy and silly, something charming.

After digging a little deeper into papier-mâché, I began teaching it, first to children and later to adults. I was so nervous before my first adult class. I thought the students would expect sculpting fundamentals and professional skills, and those were not things that I could offer!

Fortunately, my fears went away quickly. That class made the cutest things, including a sculpture of a penguin standing on an iceberg. Over the years, my students have created beloved pets, their favorite foods, narwhals, panda bears, and even a giant bottle of hot sauce!

Papier-mâché is a wonky art. It's off kilter and askew...perhaps a little kooky. That's where the charm lies. It's possible to achieve sculpting perfection—symmetry, smoothness, accuracy—but that's not my approach. Using the humblest of materials, I hope to teach you to delight in the chunky, the lumpy, and the fanciful.

I do believe that anyone can make the projects in this book. You don't need drawing skills to make papier-mâché sculptures. I find that I can get caught up in perfectionism when I'm painting or drawing, but when I put papier-mâché sculpting materials on my table, my hands take over and my brain chills out. This happens with my students too. There is an intuitive aspect to the sculpting process. Often, the materials will help you determine the shape of your sculpture. Follow their lead! Curiosity is the most important thing.

Jumping in and making the projects in the book that intrigue you first will teach you the most. Once you learn the basic approach, you'll have everything you need to sculpt your own projects. All of the techniques can be translated into different ideas, sizes, and inspirations you may have. Making inspires ideas, so you might find yourself trying one of the projects in this book and wondering if you could take another approach to make something different that only you could imagine. That's how it works—you just have to begin.

Let's start together!

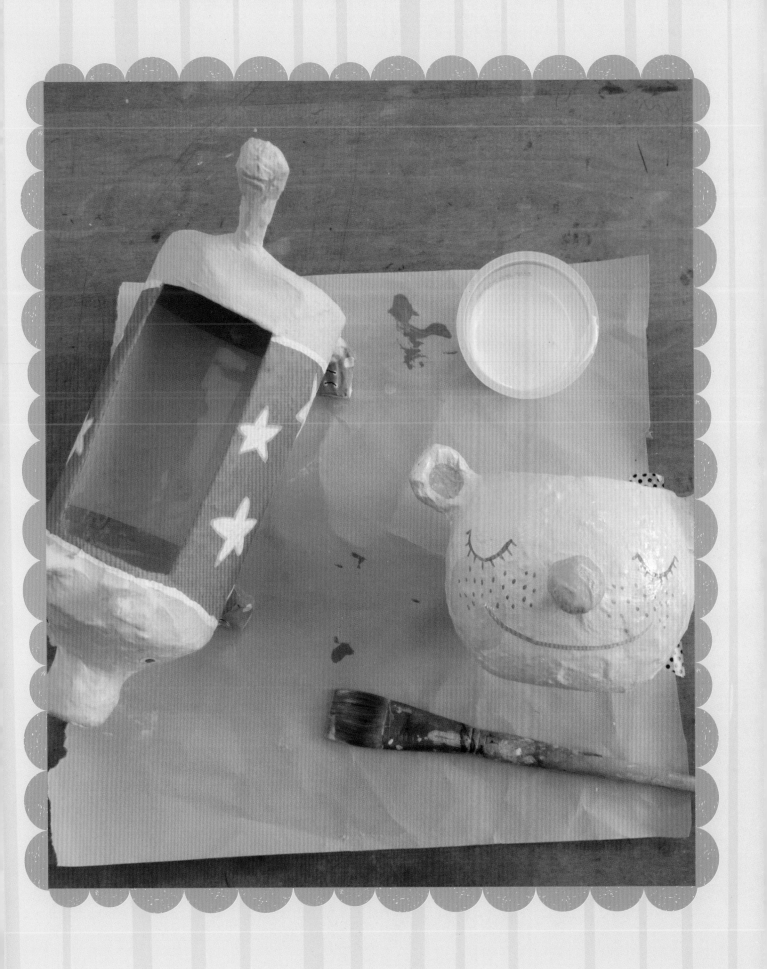

Tools & Materials

Papier-mâché is an extremely accessible art form—you may already have most of the supplies you need to make the projects in this book! Here I've provided a rundown of the necessary items, including specific ones for some projects.

PAPER

Newspaper and **newsprint or packing paper** are essential to papier-mâché and armature building (the structure underneath the sculpting material that's used for support and strength), so keep a pile on hand at all times.

Newspapers are ideal—they're cheap or free and abundant! If you don't get a newspaper at your home, ask around and find someone who will give you theirs. Newspaper can also be used to protect your work surface from messy paste and paint.

Brown paper bags work well for papier-mâché. They dry super strong and build up quickly. You will find that some have a sheen—that's a sizing in the paper that can make the bags a little less absorbent. To fix that, crumple them up a few times to soften the paper before tearing.

Scott® Blue shop towels are extra-strong, very absorbent paper towels sold in hardware and automotive stores. They build up quickly and have a lot of stretch. Unlike other papers, shop towels have some give, so you can get them to hug the curves of your armature. They can be a little fiddly and wrinkly, but if you take your time, you can achieve a nice, smooth effect with blue shop towels. One roll will be more than enough for many small projects.

MAKING PASTE

You will need the following supplies to make paste.

* Whisk: a must for lump-free paste!

* Bowl: Use a heatproof metal or ceramic bowl if you're making cornstarch paste (page 15), or a plastic bowl for flour paste (see page 15 for more on both types of paste). Use a mixing bowl even if you're making a smaller amount of paste; it gives you room to whisk without flinging flour all over the place.

* Pot or tea kettle: for boiling water. I use an electric tea kettle, but a pot of water on the stove works just as well.

* Measuring cup

* All-purpose flour or cornstarch

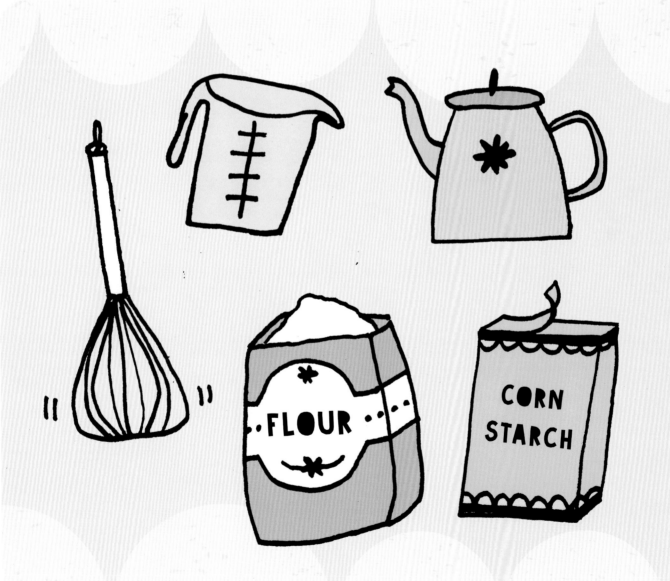

OTHER MATERIALS

Masking tape: Scotch™ is my preferred brand, and I like to use a 1-inch width, but you can also find wider rolls. You want a tape that's super sticky and strong. The tape is an integral part of the sculpting process, so experiment with different brands and see what works best for you.

Other materials you will need for armature building include:

Packing paper

Bubble wrap

Plastic bags from the grocery store

Hot glue

Cardboard: Use cardboard that's free of food and grease—so no pizza boxes. Some suggestions include:

❋ Corrugated cardboard from recycled boxes

❋ Thin chipboard from cereal and other food boxes

❋ Thicker chipboard from the backs of sketch pads and notepads

Pencil and eraser

Aluminum foil: Foil is a superb sculpting material. Make sure to use regular foil, not heavy duty, as it can be a little hard on your hands.

Ruler

Craft knife or box cutter: Cutting cardboard can quickly dull a blade; make sure to have extra.

Awl or a sharp, thick needle: An awl works best and is easier on your hands.

Scissors

Wire: My favorite is the green floral wire you can find at any craft store. I like to have 18- and 22-gauge on hand.

Wire cutters

Sandpaper/sanding sponge blocks (medium grit)

Pliers

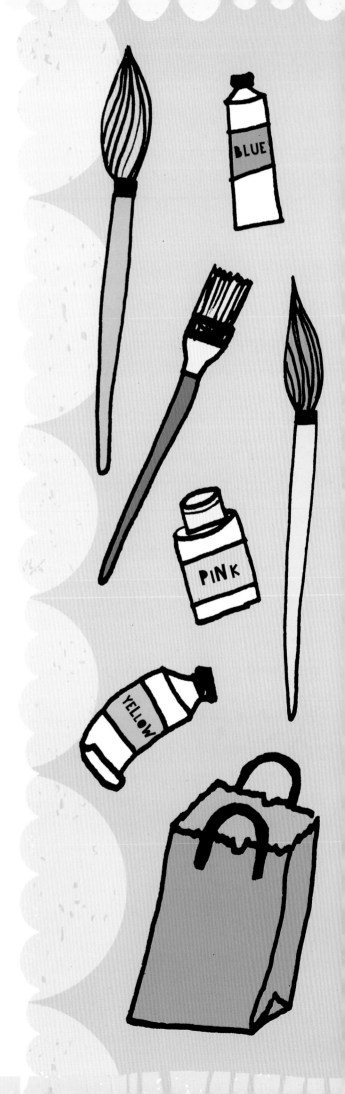

PAINTING MATERIALS

Paintbrushes: Have a selection, including a wide, soft, flat brush and a couple of different sizes of round brushes. If you don't have paint markers, a small detail brush makes a great alternative.

Gesso

Paints: Acrylic is the best paint for papier-mâché. It's permanent when dry, which makes it easy to layer without it turning muddy. The plastic quality of acrylic paint also adds some extra protection and sealer to your papier-mâché. Any kind of acrylic paint works well, from 2-ounce bottles of craft acrylics to the fanciest artist-quality tubes.

Acrylic paint pens: These are not required for the projects in this book, but I use them a lot because they make it easier to control certain details, like eyes and little dots and lines. If you find yourself curious about acrylic paint pens and are open to buying new art supplies, here's some information:

✳ Buy one or two and see how you like them before you commit to a whole set. A white one is really nice to have too.

✳ There are many brands out there. Just make sure you're getting water-based pens, not oil-based (those are the smelly ones).

✳ There are different sizes of nibs, but medium and fine are my go-tos.

✳ I mainly use Sharpie® brand and POSCA.

Mod Podge® Hard Coat: My favorite sealer, this product dries quickly with a satin finish and cures to become water resistant. It goes on milky but dries clear. It self-levels, so you don't see brushstrokes, and it provides a wonderful protective finish.

Other finishes/sealers: If you don't have access to Mod Podge Hard Coat or you'd like a different sheen, there are lots of sealers to try. Matte, gloss, satin, spray, brush-on—from artist-grade to the ones from the craft store, they're all good. If you use spray sealers, make sure you do it outdoors with plenty of ventilation. For liquid sealers, apply with a soft brush, which leaves a smoother finish.

EVEN MORE STUFF

Cutting mat: to protect your work surface when you cut cardboard.

Water jar: for glue brushes and paintbrushes.

Parchment paper: for drying sculptures in the oven.

Palette or paper plates: for mixing paint.

Thin dowels or skewers: Make sure they are at least ¼ inch thick. Bamboo skewers used for cooking are great.

Wooden blocks or wood slices for stands: You can buy wood slices and blocks at craft and hardware stores. If you're super handy, you can make your own wood slices from branches and a saw—but watch those fingers!

Pipe cleaners or chenille stems: Chenille stems from the craft store come in many colors. If you like the fluffy look of cotton pipe cleaners, they can be found at tobacco stores and online. You can dye them with watered-down paint or ink for a fun way to customize your work!

Pin backs: I use 1-inch pin backs, but there are many sizes available to suit your pin designs.

Beads: You can use any beads for projects like "Birds on a String" (pages 84-91), but I like 6/0 glass seed beads because you can thread a thick waxed cord through them without using a needle.

Glitter: If you like sparkle, use it wherever you want! If you can't stand the mess, it's totally optional.

Collage paper: This can be anything you have on hand, including scrapbook paper, old book pages, and origami paper.

Felt for pin backing: Really, any thick fabric that won't ravel works well.

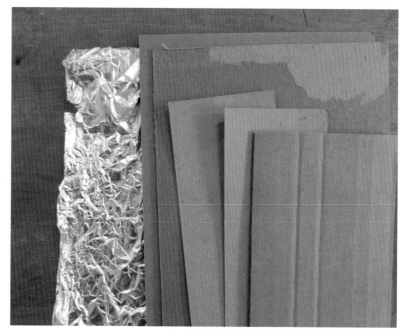

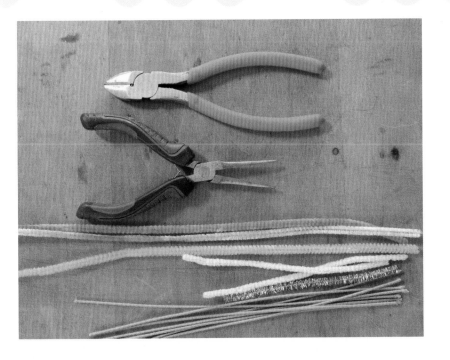

Clean, plastic, recyclable containers: These are used in the planter project (pages 24-33). I like to keep containers that have interesting shapes.

Cups or lids for glue and sealer: I decant my glues and sealers into small containers so that I don't contaminate the whole jar. Plastic lids and other small containers that you'd normally recycle are perfect. If any remnants of glue dry in your containers, you can peel out the glue and reuse the container.

Waxed thread: linen or polyester. Waxed linen thread can be found in most jewelry-supply sections of craft stores, and waxed polyester thread is found in the upholstery section of fabric stores.

Foam core board: The dollar store is a great place for this.

Wooden plaques: Plaques that you find in craft stores come in many fun shapes and are relatively inexpensive.

Ribbon or fabric strips: These are for the cuffs of papier-mâché figures' clothing. I like to tear strips of fabric for a frayed look, but ribbon gives you a more finished look. The look is up to you!

Empty tape rolls: for bracelets!

Leather cord or ribbon: for beaded necklaces.

Bells: These can be found at most craft stores.

Boxes/box lids: for the "Wall Pocket Pal" project on pages 42-47.

Metal hook with two prongs

Craft foam

Tacky glue

Drill and bits

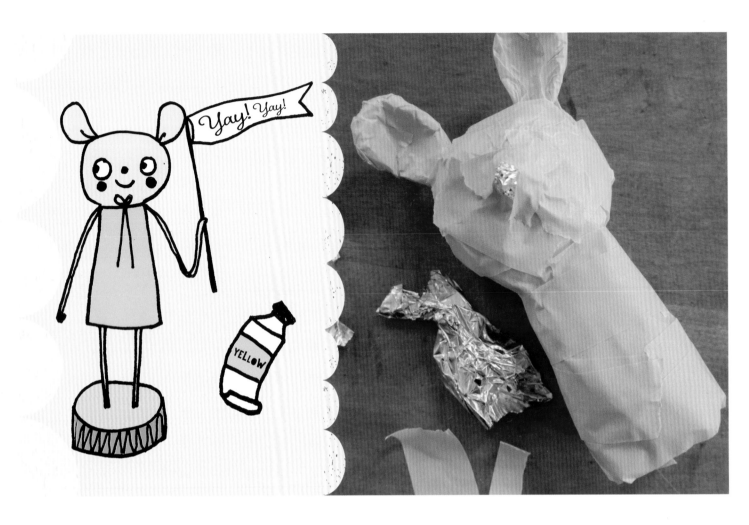

Techniques, Recipes & Drying

We discussed the tools you need for papier-mâché on pages 6-11. Now let's learn how to use them!

Armature building An armature is the structure underneath sculpting material that's used for support and strength. Papier-mâché requires an armature, to which the paper and paste adhere. Simple materials make up our papier-mâché armatures.

Cardboard cutting A cutting mat protects your work surface when cutting cardboard. Use a box cutter or craft knife and go slow. If you're cutting a straight line, it's helpful to use a metal ruler as a guide. Watch your fingers and use sharp blades!

Cardboard loosening Corrugated cardboard is great, but sometimes it needs more flexibility. Just roll it up backward and forward to loosen it up. Make sure you're rolling with the corrugated lines parallel to your roll; this will soften your cardboard and make it easier to manipulate.

CRUMPLING PAPER & TAPING

This is my most-used technique. It's intuitive, and once you have the hang of it, you'll find you can make anything! It's just what it sounds like: Simply crumple paper and tape it into shape. Keep the crumple a little loose (not crushed into the tightest ball you can make) so that you can shape it as you tape. This technique works best if you build up the sculpture with components of crumpled and taped shapes, and then tape them together.

Taping to hold pieces together Use long pieces to join two parts of your sculpture. Make sure to press the tape down well along the contours of the sculpture.

Taping for strength Tape is an important part of the papier-mâché-making process and is used for strength and cohesion. If you view the armature as the skeleton, think of the tape as the muscle that keeps everything protected and strong. Cover your sculpture completely!

Taping for stickability Tape also makes a better surface for the papier-mâché to stick to. Taping over plastic, foil, or wire helps the papier-mâché stick much better and prevents wire from rusting. Taping paper and cardboard prevents the papier-mâché from getting soggy.

Taping to fix holes and dips Sometimes your armature will have a dent or dip that you want to fill out. It's an easy fix: Crumple a bit of tape about the size of the spot you want to fill, stick it on, and tape over it.

SCULPTING WITH FOIL

Foil is an accessible and easy-to-use material for sculpting. It works wonderfully for the parts of your armature that must be strong, like legs and other supports. Because it can be bent and curved, foil also gives you a lot of control over the shapes you want to make. It can be a little sharp and pokey on the hands, but if you're careful, you'll be fine.

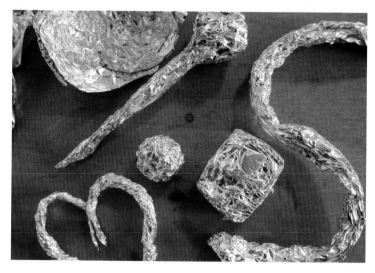

To shape my foil armature, I tear off a sheet of foil and squish it down (like crumpling paper), and then use my fingers to pinch it into shape. You can roll the foil between the palm of your hand and a table to apply more pressure. You can rub it against a tabletop to make a dense, flat surface. You can make long, snakelike shapes, and then bend them to your will. Think of foil as super-thick, easy-to-bend wire!

If you squeeze down your foil and it ends up too big, just open it back up and tear a little bit off until you get to the size that you need. One thing to remember: whatever you sculpt out of foil must be substantial enough to hold its own shape. Once you have formed shapes that you like, hot glue them to the rest of your armature. Make sure to add tape over everything!

PAPER TEARING

The only hard and fast rule I have for papier-mâché is about the paper. No matter the paper choice, you must tear it—don't cut it. Tearing it gives the paper feathery edges that melt into each other and create a unified-looking outer shell. Cut paper creates hard edges that distract from the finished piece. Trust me on this one!

How big and what size should the torn pieces be? A good rule of thumb is the larger the sculpture, the larger the pieces of paper you need. The smaller the project, the smaller the pieces of torn paper. You will need to experiment with this. You may find that the paper needs to be torn into smaller pieces if you aren't able to smooth and manipulate it onto the armature.

Should you use strips? Squares? It doesn't matter! Tear the paper however you like and try it out. Mix up the shapes you tear. The important thing is to cover the armature with layers of torn paper and paste to create a strong shell.

Experiment with types of paper to see which one you love. You can use more than one type of paper on a sculpture!

MAKING PASTE

Paper and paste are necessary for making papier-mâché. Together, they form the outer shell of your sculpture and serve as a strong exoskeleton to keep all of the parts of your armature unified. I use traditional homemade paste and have included two recipes for you to try. These pastes are tried and true and I use them all the time with my students and in my own work. I hope you'll try both and see which one you like better.

FLOUR + WATER

Making paste from flour and water is easy, quick, and cheap, and it uses materials you usually have on hand. It dries hard and strong and is so easy to whip up.

STEP 1

Measure 2 cups water into a mixing bowl.

STEP 2

Whisk in 1½ cups flour, a little at a time until the paste has the consistency of pancake batter—not too thin, but not doughy! It should be smooth.

Tip

If the flour-and-water mixture looks foamy and bubbly, it's too thin and needs more flour. Slowly whisk it in.

CORNSTARCH + WATER

Cornstarch paste is a smooth, refined paste that's thicker than the one made from flour and water. It requires a bit more work to make, but it's still fast and easy.

STEP 1

Measure 1 cup cornstarch into a metal or ceramic mixing bowl.

STEP 2

Whisk in 1 cup tap water and dissolve the cornstarch. It will look like milk.

STEP 3

Boil about 6 cups water.

STEP 4

Remove from heat and slowly, carefully, and quickly whisk the water into the dissolved cornstarch. It should thicken and become translucent. Keep whisking until the mixture has a thick, goopy, uniform texture. Let the mixture cool to a safe temperature before using it.

Tip

If the mixture gets too stiff, slowly whisk in more hot water, a little at a time, until you get a thick but not chunky consistency.

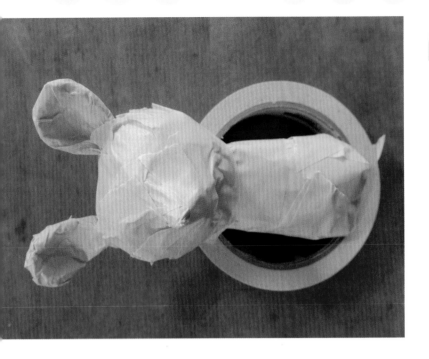

USING PAPIER-MÂCHÉ

Now that we have torn paper and a bowl of paste, it's time to papier-mâché!

Dip a piece of torn paper into the paste. When you lift the paper out of the paste, keep holding it over the bowl and, using your other hand, squeegee it off between your first and second fingers. The paper should be soaked through with paste but not dripping. Be generous here—don't use paper that's too dry. Your sculpture will end up weaker and less smooth.

Tip

If your hands aren't messy, you're probably not using enough paste! Dig in there!

Now, smooth that piece of paper onto your armature. Repeat, overlapping the edges of the papers, until you have one layer completed. I recommend two layers minimum. You can add the next layer on top of the first wet layer; there's no need to dry in between layers.

Tip

When making multiple layers, use one type of paper and switch to another for the next layer so that you know when you've completely covered each layer.

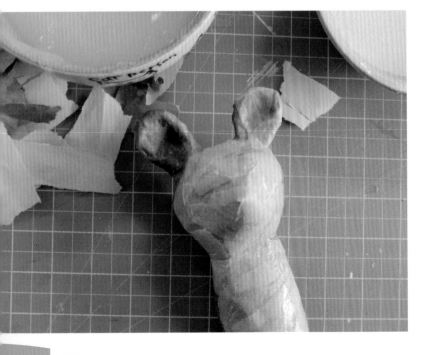

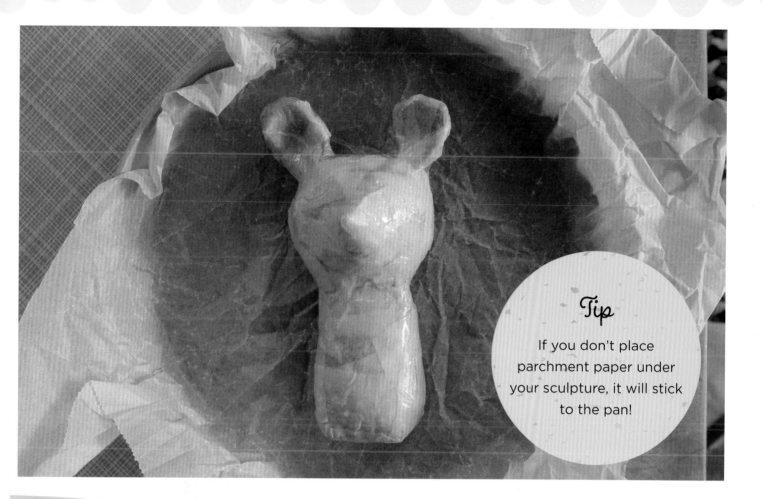

Tip

If you don't place parchment paper under your sculpture, it will stick to the pan!

DRYING

Your sculptures must be completely dry before you prime and paint them. If they aren't dry, the paint will not stick and the sculpture may mold. If it feels cool to the touch, there's probably a bit of moisture underneath, so let it dry longer. When in doubt, give it more time.

Air drying Set your sculpture in a safe spot and turn a fan on it. Make sure to rotate it, and keep the air circulating until your art is dry. It will take about 24 hours to dry.

Oven drying Smaller sculptures can be dried in the oven. But take note! Only oven dry sculptures made from foil and paper; if you've used a plastic bottle or Styrofoam, do not use the oven, as these materials can melt and give off fumes.

Set the oven very low—170 to 200° Fahrenheit, maximum. Place parchment paper on a cookie sheet and set your sculpture(s) on it. Bake in the oven for about an hour, turning halfway through for even drying. Don't leave your sculpture in the oven for too long or it may turn the paper brittle. If the sculpture isn't completely dry after an hour, give it another half-hour or hour. It can work well to get the drying process started in the oven, and then finish in front of a fan.

DRILLING

Place a protective piece of wood underneath if you need to drill a hole in something. Keep a firm grip on the item to be drilled, and watch your fingers!

Finishing & Painting

SANDING

I often sand my sculptures before painting them. Sanding for papier-mâché isn't like sanding wood—you must use a light touch. Also, sand only to take off little chunks of paste or to tone down wrinkled, folded bits. Be careful when doing this or you'll sand right down to the armature. Take a soft approach with a sanding sponge.

GESSOING

Gesso is an acrylic-based primer that's applied as a first coat. It prepares the surface to receive paint well. I recommend gessoing all of your sculptures before painting. Papier-mâché is still absorbent after it dries, so putting gesso on first protects the papier-mâché and helps your paint go on better.

The flat, white color of gesso will help make your colors pop! Gesso comes in gray, black, and clear too. I like white for bright colors, but I sometimes use clear gesso for more transparency.

PAINTING

You don't have to be a master painter to paint a sculpture. Keep it simple and use colors you love. If you're not super confident with your art skills, feel free to draw your design on the gessoed sculpture as a guideline for your paint. Papier-mâché looks so charming with a simple paint job—there's no need to make it overly complicated. And remember that if you mess up, just let the paint dry and then you can paint over it. That's the beauty of acrylic. Make it fun and don't stress!

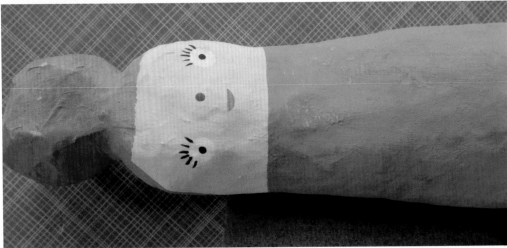

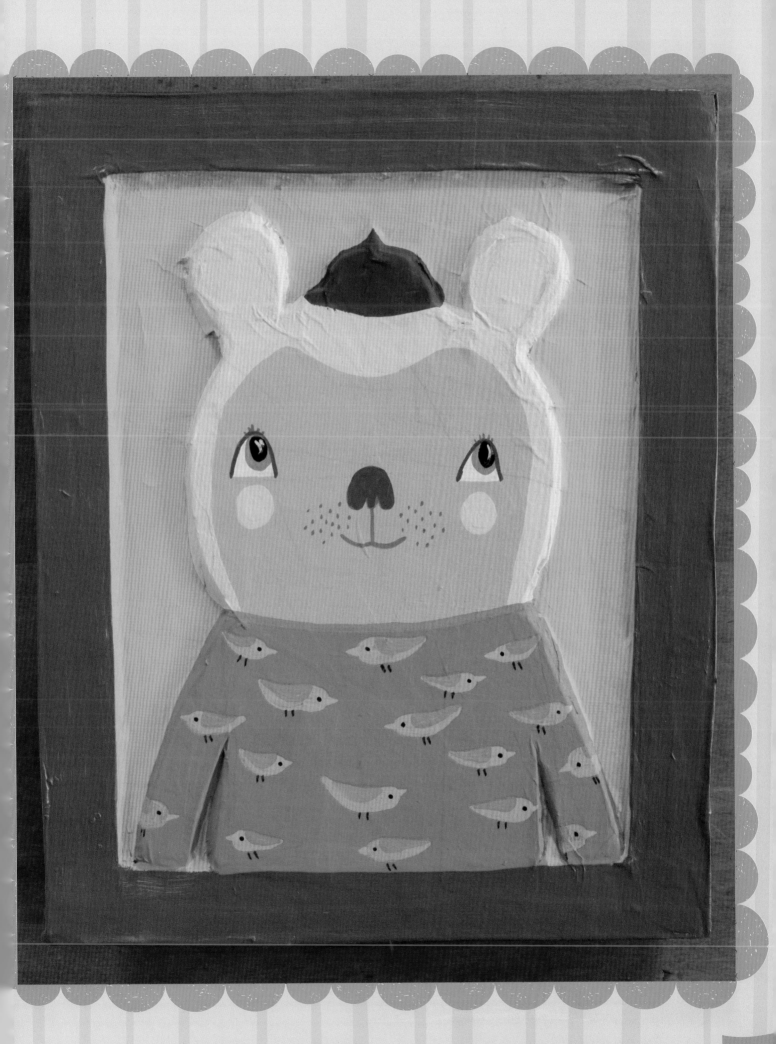

Layering paint This simply means adding a layer of paint, letting it dry, and then painting another layer or decorative pattern on top using a different color. Acrylic is perfect for this because it dries quickly and you can layer and layer and layer until you achieve your vision.

Sanding away to reveal If you like the distressed look or just want a bit more texture in your painting, try this: Paint something using one color and let it dry completely. Then paint another color on top of that one. Let it dry completely. Take a sanding sponge of medium grit and gently and gingerly sand bits of your top layer away. The underlayer will peek through and add surprising bits of color here and there. This takes a little longer, but it's a fun way to experiment. And if you scuff all the way down to the papier-mâché, know that you can repaint and try again.

Lumpy surfaces Painting on a lumpy surface is part of the papier-mâché process. No matter how much you smooth down and sand your papier-mâché, its very nature is to be lumpy! That's what we love about it, but it can make painted details a bit fiddly to achieve. My advice is to take it slow and make sure your paint has a consistency that easily flows off the brush without dripping. You can experiment by slowly adding a little water to the paint color you're using to get the right consistency.

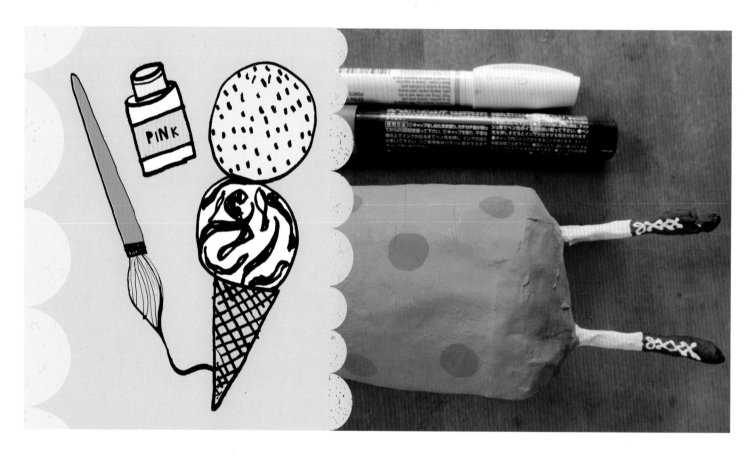

Paint pens Using paint pens is fun and easy. Make sure to shake them well before use! I think they work best for final details.

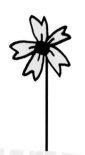 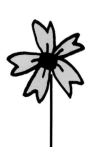 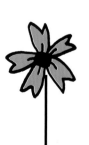 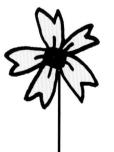

SEALING

This is your last step! Sealing not only gives your art a professional look, it also adds strength and longevity to your sculptures. Before you seal anything, make certain the paint is totally dry.

When using a **brush-on sealer,** make sure to cover your work surface. Using a soft, flat brush, brush your sculpture with just enough medium to cover and seal it without drips. You may have to seal one side of your work, let it dry, and then seal the other side. Work in stages if you need to. Don't hurry this final, important step.

Spray finish Make sure to apply this outside in a well-ventilated spot. Follow the directions on your spray for the best results.

Now, let's get started!

STEP-BY-STEP PROJECTS

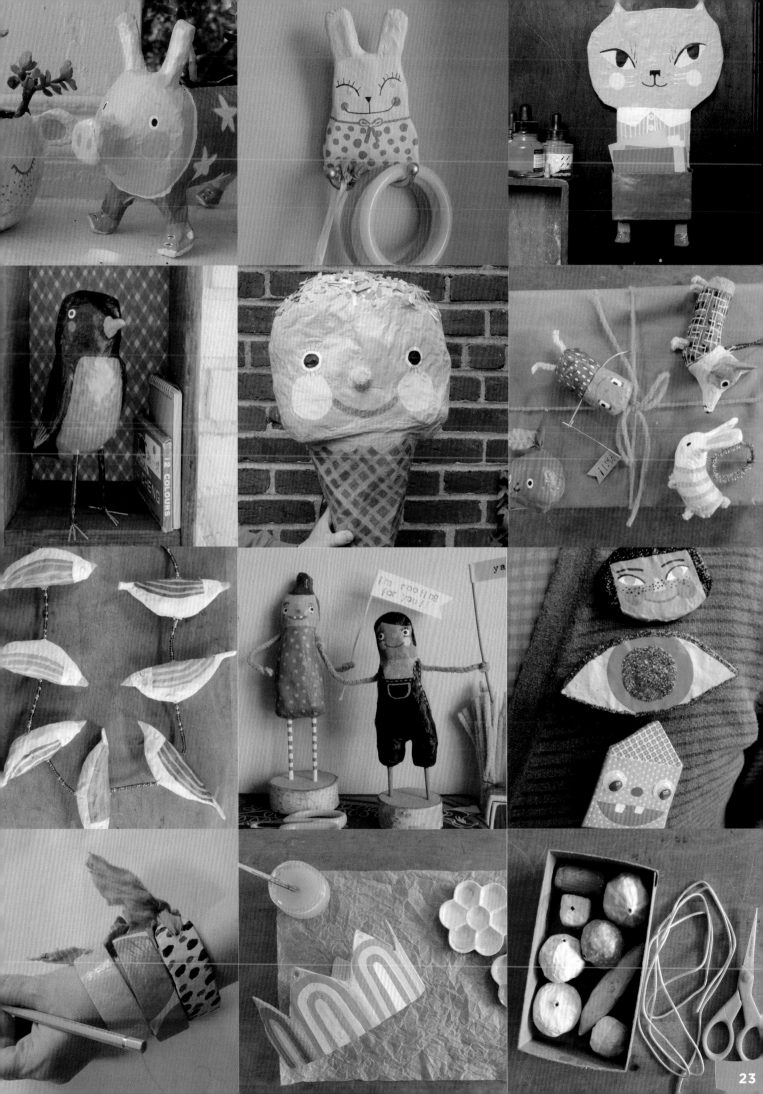

Planter

If you're a plant mom or dad, you might need more room for your little babies. Instead of buying new planters, make your own from recycled containers. You can make these to match your home décor, whether it's elegant, monochromatic, colorful, or goofy (that's my style!). If you don't have a green thumb, you can fill your planters with cute fake plants, pencils, or doodads.

TOOLS & MATERIALS

- Plastic recycled containers, such as bottles and jars
- Permanent marker
- Box cutter, craft knife, or scissors
- Masking tape

- Aluminum foil
- Hot-glue gun
- Paste
- Paper (paper bags or another strong brown kraft paper are ideal)

- Sandpaper
- Sealer
- Gesso
- Paint and paint pens

Rummage through your recycling and grab any plastic containers that have an appealing shape. Make sure they aren't too small; you don't want to squish your plants! Clean your containers with soap and water, and let them dry.

STEP 1

Give the plastic container you've chosen a good, long look. Does its shape inspire you? Turn it sideways and right side up. See if its shape suggests an object, a figure, or an animal. Now make some rough sketches to visualize how to add sculpted details to your vessel. (Mine's going to be a cute animal!)

STEP 2

Use a permanent marker to mark where you'll cut the planter from your plastic container.

STEP 3

Cut the planter from the plastic container. Be careful—plastic is slippery!

Place tape around the plastic container to help the papier-mâché adhere and prevent the plastic from melting when you hot glue it later.

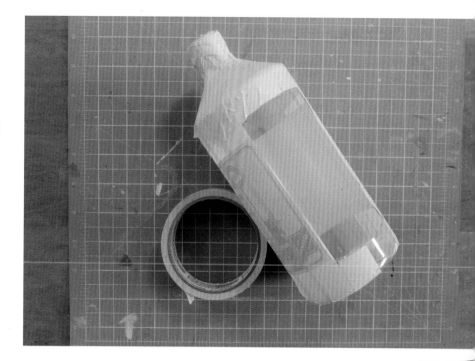

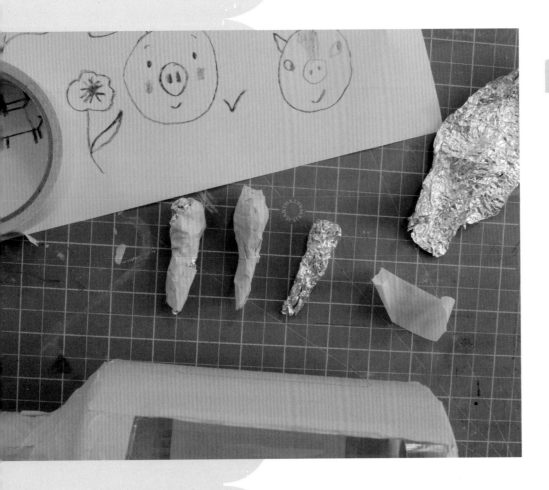

STEP 4

Sculpt using the aluminum foil. First, form anything that will go on the body of the animal, such as ears, tail, and so on.

Add ears and a tail made from squished and pinched foil, tape them, and hot glue them on. Place tape around anything you attach.

STEP 5

To make legs, squish the foil so that it's super dense and strong. Tape up the legs and hot glue them to the container, ensuring that they can hold up the container and that all feet touch the surface beneath them.

STEP 6

Get that paste and papier-mâché ready! Brown paper bags are the best choice for this project, but either kind of paste will do. Before you mix, add 1 tablespoon of white glue or Mod Podge Hard Coat per 1 cup of paste. This makes the paste a bit more durable, which is ideal since the planter will get wet.

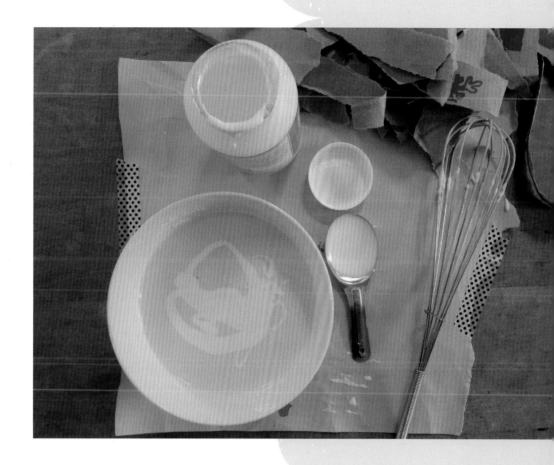

STEP 7

Add at least two layers of papier-mâché to the entire planter, using smaller pieces for details. Add a third layer where the legs meet the body. Create a finished edge on the lip of the planter by folding ¼ inch of papier-mâché over the edge.

Let dry completely by setting the planter in front of a fan for 24 to 48 hours. Do not place the planter in the oven or it may melt.

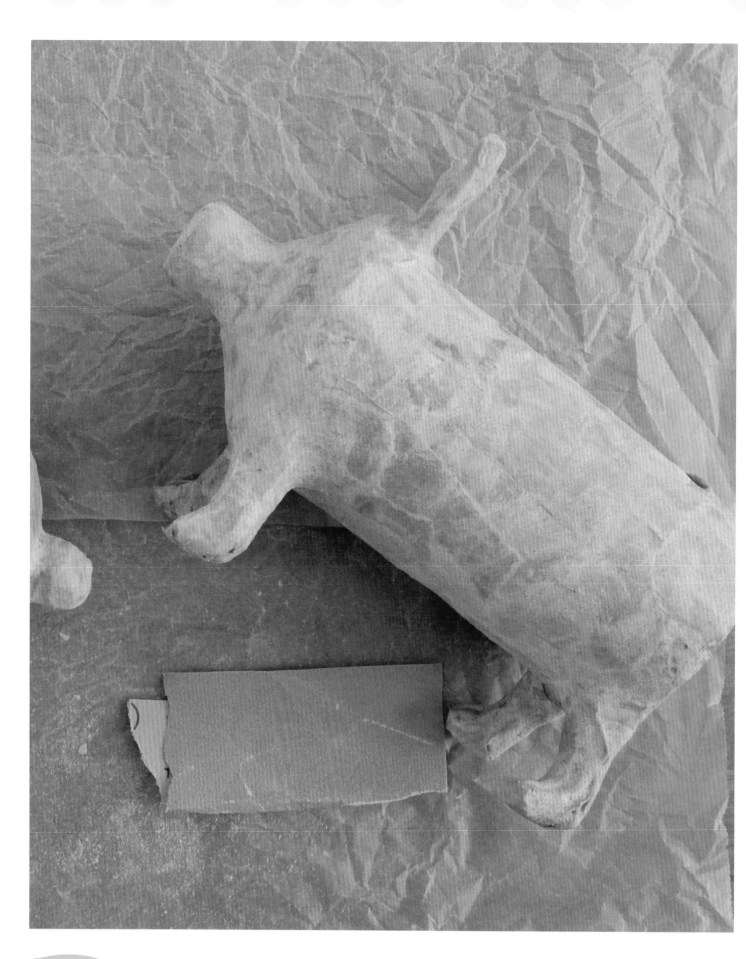

STEP 8

Sand the planter if necessary.

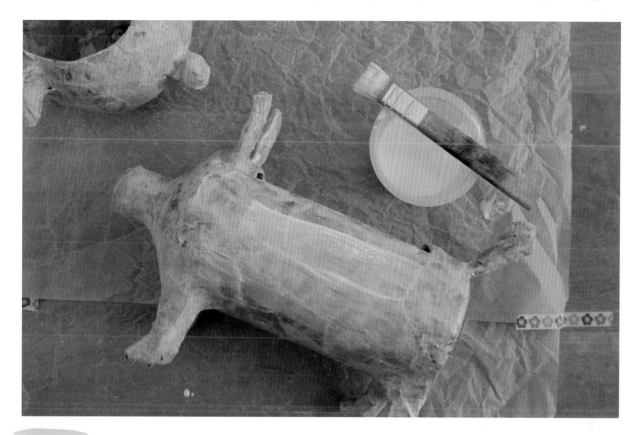

STEP 9

Paint water-resistant Mod Podge Hard Coat or another waterproof but paintable sealer on your sculpture. Let it dry overnight.

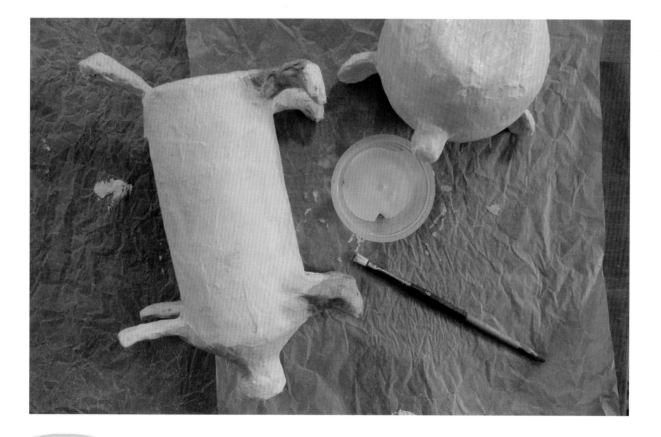

STEP 10

Add gesso and let it dry.

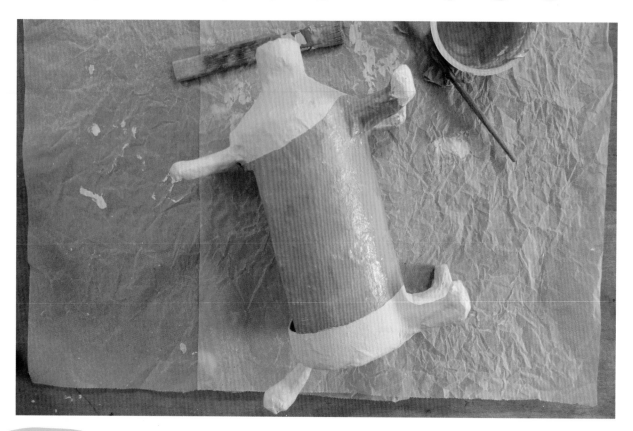

STEP 11

Paint the planter.

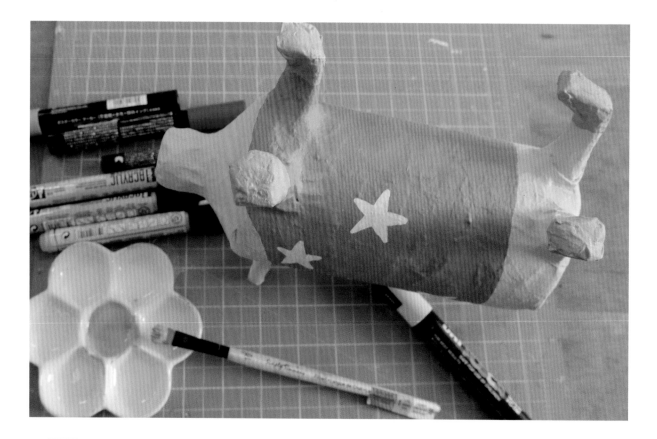

STEP 12

Add details using paint pens. Let dry completely.

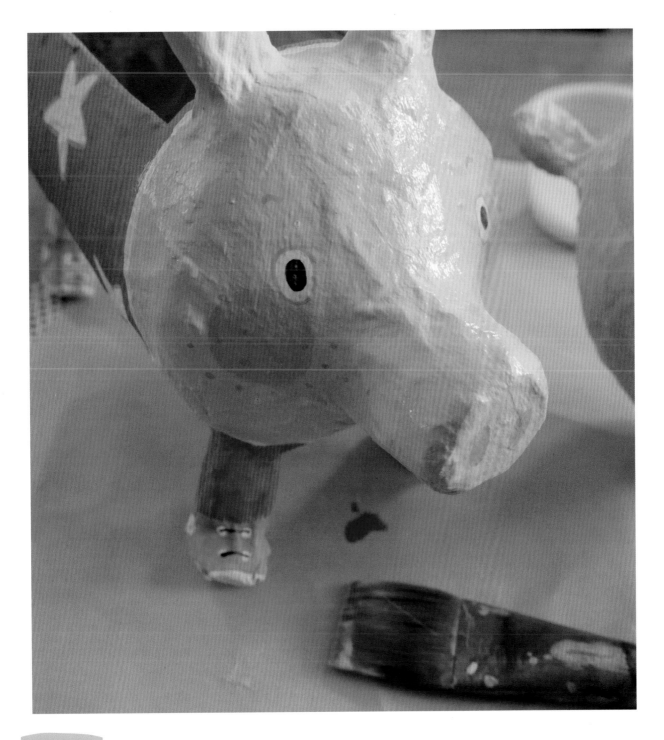

STEP 13

Apply two coats of sealer, letting the first layer dry before adding the second. Don't forget to add sealer to the papier-mâché you folded over the inside of the planter lip as well. It should hold up fairly well over time if you add sufficient sealer.

Let the sealer cure according to the manufacturer instructions. It's worth the wait to protect your wonderful piece of art!

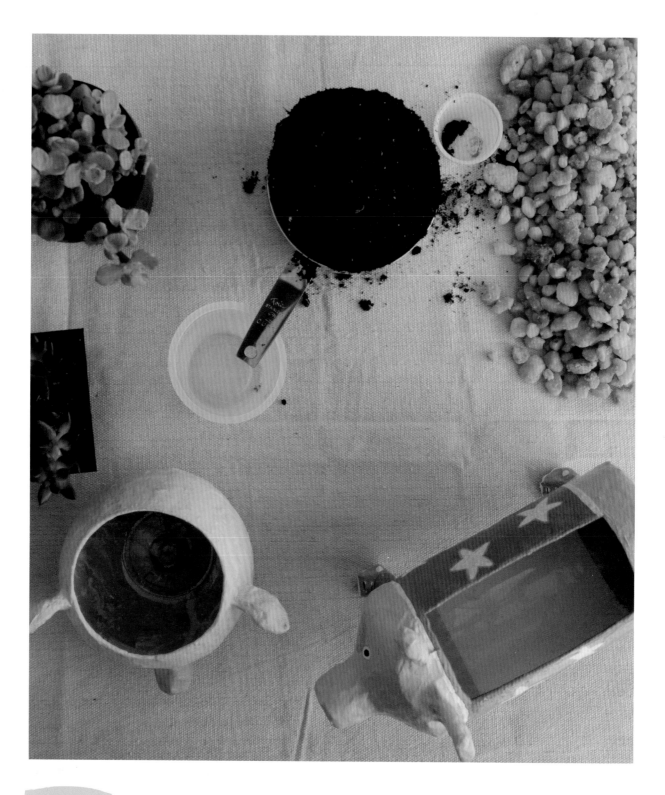

STEP 14

Plant your friends!

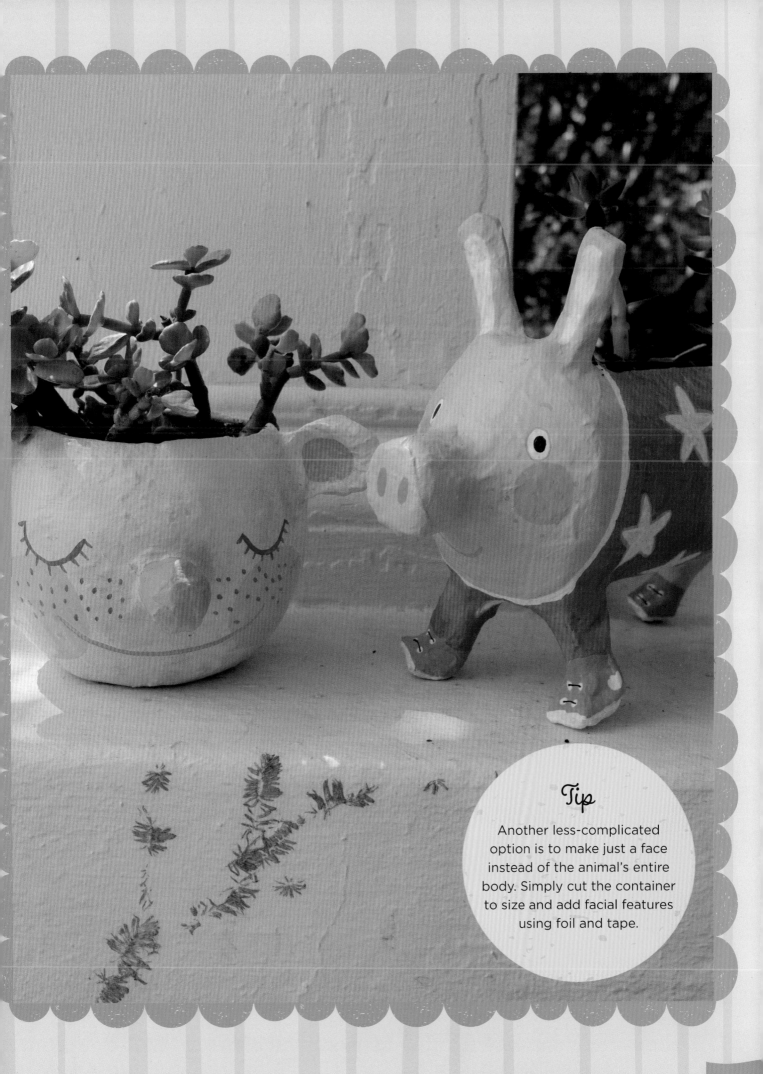

33

Tip

Another less-complicated option is to make just a face instead of the animal's entire body. Simply cut the container to size and add facial features using foil and tape.

Hook

I don't know about you, but I always need more hooks in my life. Keys, scarves, cardigans—they all need somewhere to hang out! Let's make something cute to store your stuff. You will use a store-bought hook for the base and add papier-mâché to bring a bit of fun to a standard organizational tool.

TOOLS & MATERIALS

- Hook with two side-by-side screw holes
- Corrugated cardboard
- Craft knife
- Hot-glue gun
- Awl or scissors

- Strong, thin wire
- Masking tape
- Paper (brown paper bags and shop towels)
- Paste
- Sandpaper

- Gesso
- Paint and paint pens
- Sealer
- Optional: thick felt or craft foam

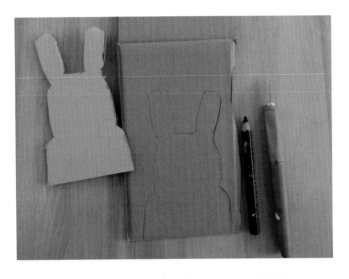

STEP 1

Gather your supplies and draw the design for your hook onto a piece of corrugated cardboard. I've made the head and shoulders of a rabbit, and I'll secure the hook to the base of my design (the rabbit's shoulders). The wall-plate part of the hook is about 1 inch wide, and I've decided to make the base of my rabbit character 3 inches wide.

Cut out the cardboard design; then trace the shape onto another piece of cardboard and cut it out so that you have two designs.

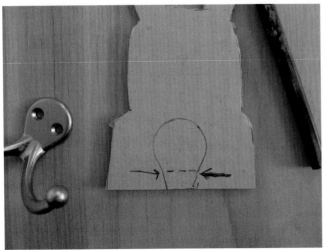

STEP 2

Trace the wall-plate part of the hook onto one of the cardboard cutouts, and cut the bottom part from the cardboard. This will make the finished hook look less lumpy. Set aside.

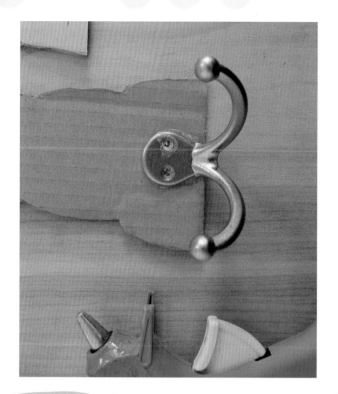

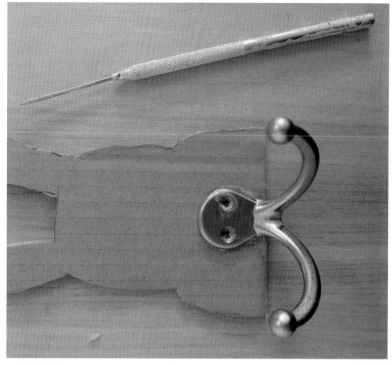

STEP 3

Hot glue the other shape to the back of the hook plate. If glue gets into the holes of the metal hook, wipe it out with a scrap of cardboard.

STEP 4

Using an awl or a pair of pointy scissors, poke through the holes of the plate to the cardboard.

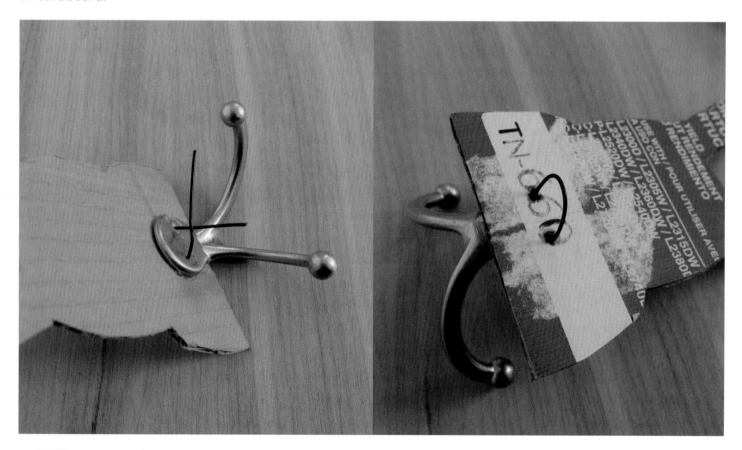

STEP 5

Thread a piece of strong wire through the holes of the hook, toward the front. Leave a small loop of wire on the back, as shown.

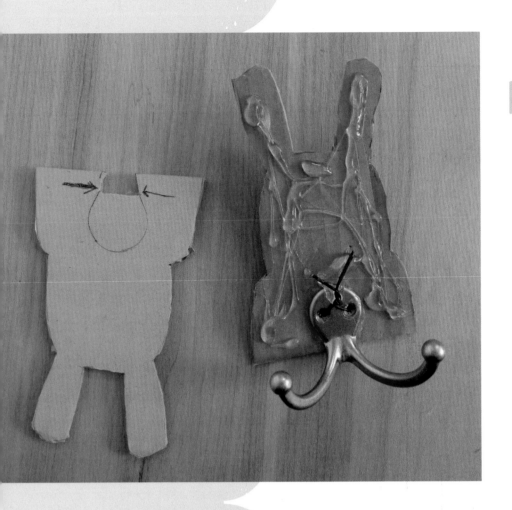

Twist the cut ends together securely and turn the twisted wire up; then secure with hot glue.

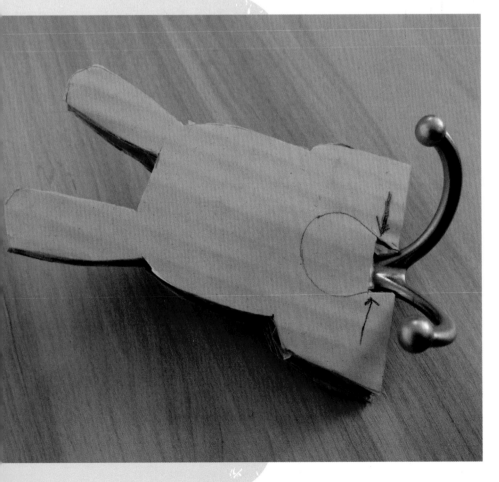

STEP 7

Hot glue the two cutout shapes together, with the hook plate and twisted wire ends between the cutouts.

STEP 8

Apply masking tape to the entire object. Make sure the edges have a neat, clean edge.

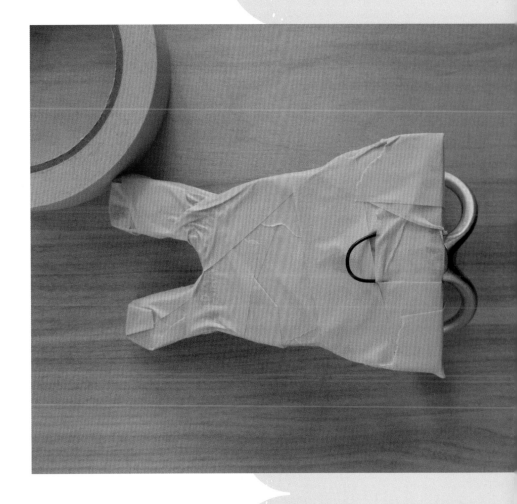

STEP 9

Tear up the paper and make paste. Then apply two layers of papier-mâché to the entire object. It doesn't need to bear the weight of what you hang from the hook—but do make it strong!

Notice that I used two different papers in this project. I do this when I feel the properties of one paper will work better than another. Here, because of the stretchiness of the shop towels, I've used them on the tight curves of the rabbit's ears, with brown paper bags elsewhere.

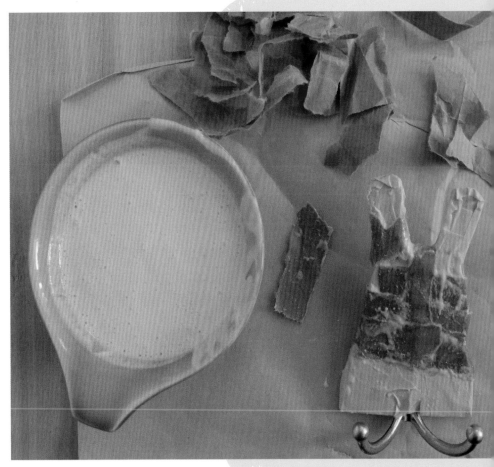

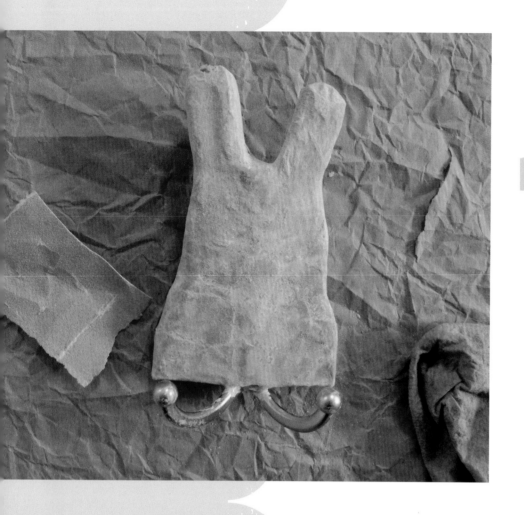

STEP 10

Sand the papier-mâchéd part of the hook after it dries. If there is any paste residue on the metal hooks, use a damp paper towel to wipe it off. It should come off easily.

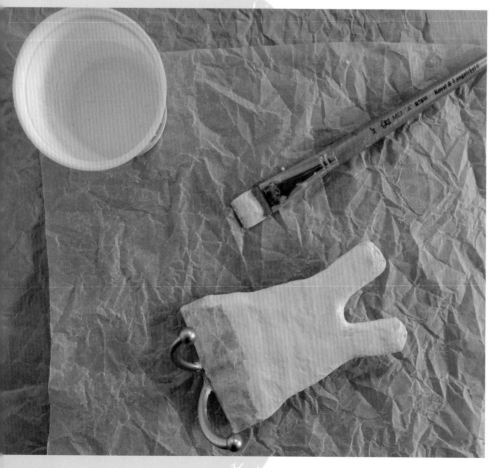

STEP 11

Gesso the whole object, except for the hooks.

STEP 12

Get out your paints, brushes, and paint pens, and start painting the personality on your hook buddy. Keep a damp paper towel handy to wipe off any stray paint that gets on the hooks.

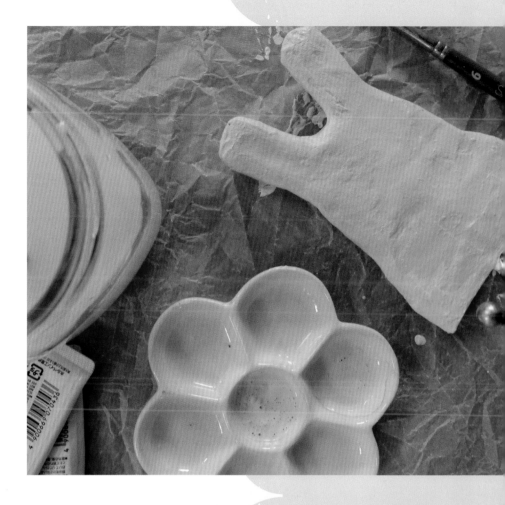

STEP 13

Add details with paint pens.

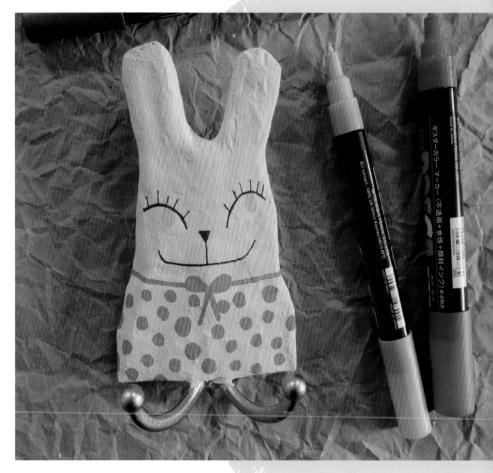

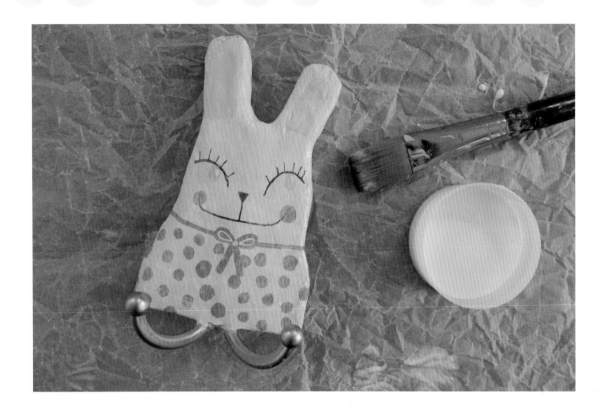

STEP 14

Seal with the finish of your choice. It's a good idea to use several layers of sealer if you plan to use the hook often.

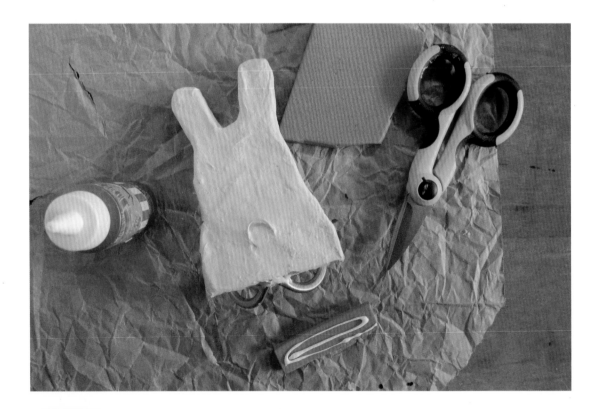

STEP 15

This step is optional, but it will give your project a nice finish! Because the hook won't be mounted flat against the wall and will tend to lean forward a bit, it's a good idea to add a bumper at the bottom. Simply cut a small strip of thick felt or craft foam and glue it under the hook loop on the back using craft glue.

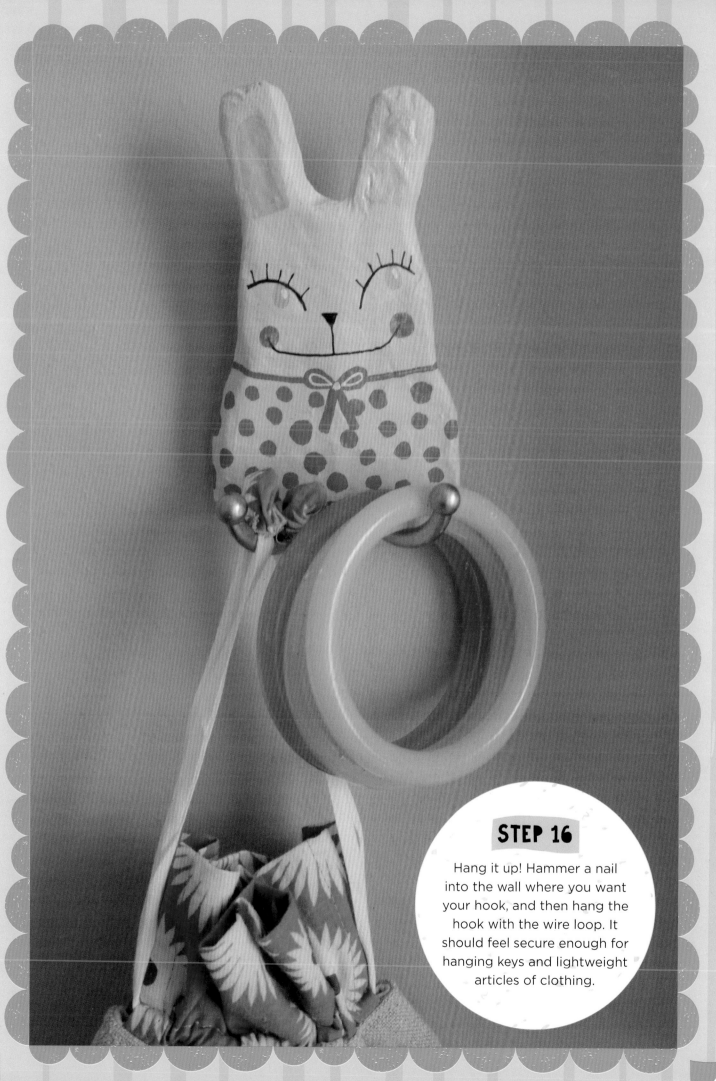

STEP 16

Hang it up! Hammer a nail into the wall where you want your hook, and then hang the hook with the wire loop. It should feel secure enough for hanging keys and lightweight articles of clothing.

Wall Pocket Pal

Need cute storage? Whip up this sweet wall pocket! It's perfect for keeping business cards at the ready or storing all the bits and bobs that you collect on nature walks.

TOOLS & MATERIALS

- Small box or box lid (such as the lid from a box of markers)
- Corrugated cardboard
- Craft knife
- Hot-glue gun
- Wire and wire cutter
- Masking tape

- Paper (brown paper bags)
- Paste
- Sandpaper
- Acrylic paint and paint pens
- Sealer

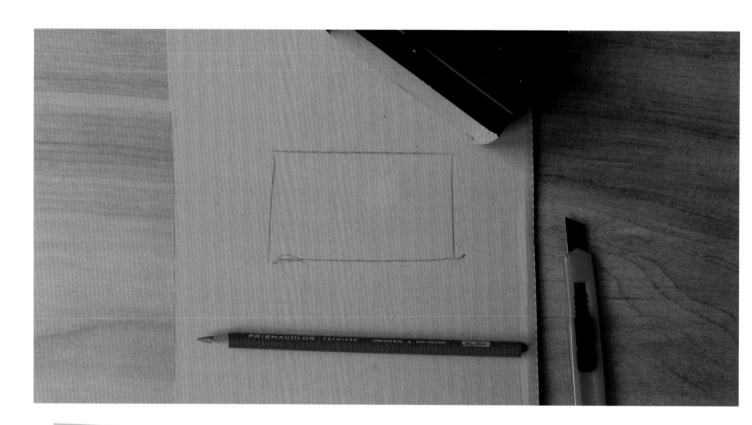

STEP 1

Trace the back of your small box onto a piece of cardboard. Reserve the box for step 3.

STEP 2

Draw your animal pal using the shape you just traced; then cut it out with a craft knife. You can make this as simple or as detailed as you wish. I like to add legs!

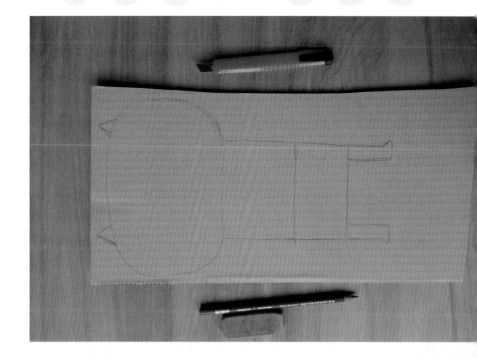

STEP 3

Use a hot-glue gun to glue the box to the cardboard shape you just cut out. Use a hot-glue gun to glue the box (open side up) to the cardboard shape you just cut out.

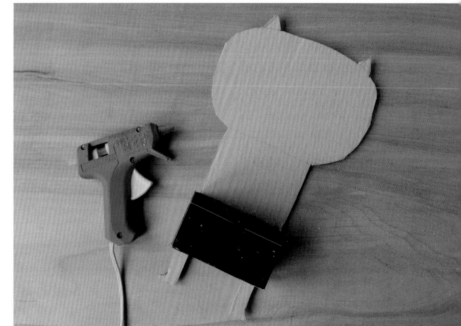

STEP 4

Make a hook by cutting a piece of wire and shaping it as shown in the photo. Hot glue the two prongs to the upper-back area of the cardboard.

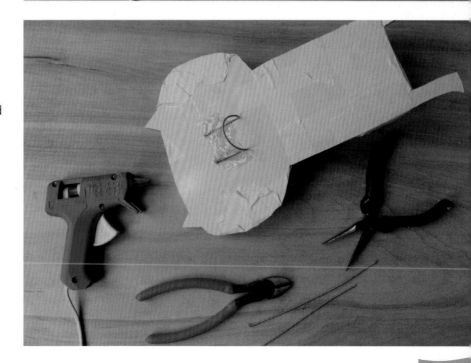

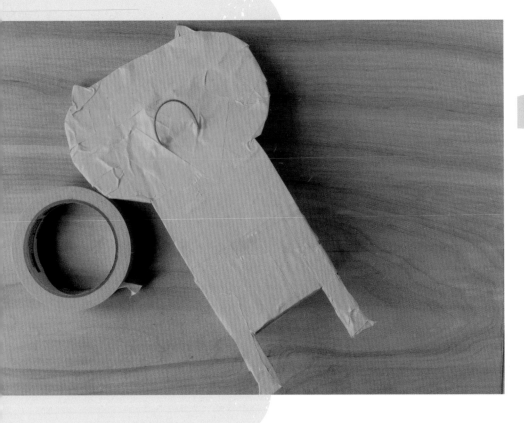

STEP 5

Cover the entire animal shape with masking tape, including inside the box. Add a little extra tape to the glued part of the hook on the back; you need it to be strong.

STEP 6

Use two layers of material from a brown paper bag to papier-mâché the entire shape. Let it dry completely.

STEP 7

Lightly sand any sharp bits.

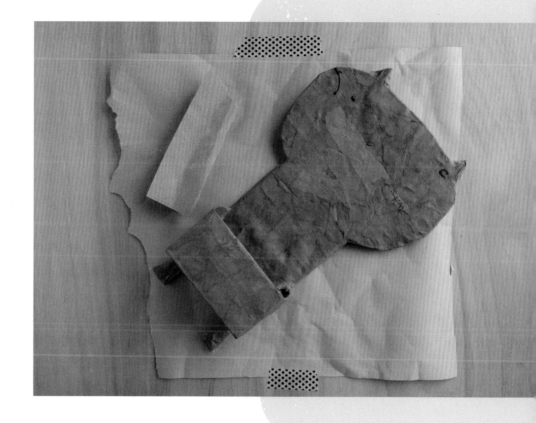

STEP 8

Gesso your animal, and let it dry.

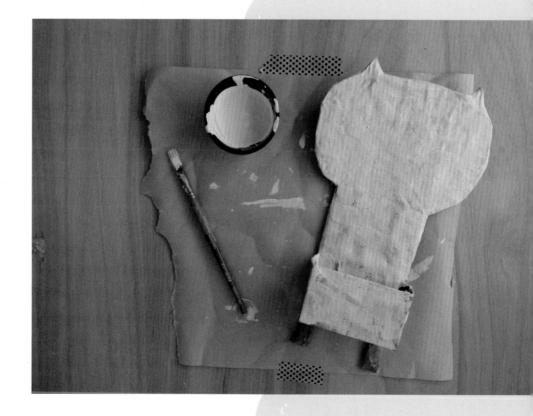

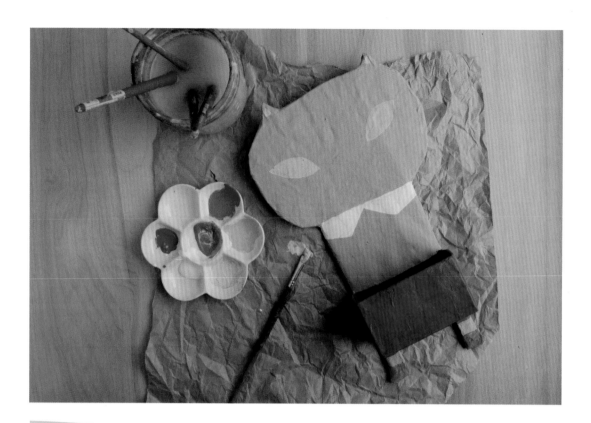

STEP 9

Paint larger areas with acrylic.

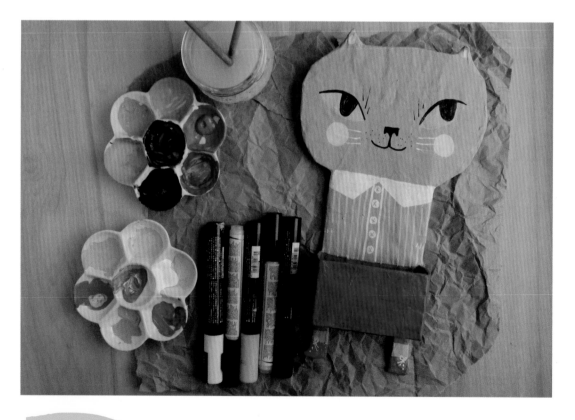

STEP 10

Add details with acrylic paint pens. Seal and let dry.

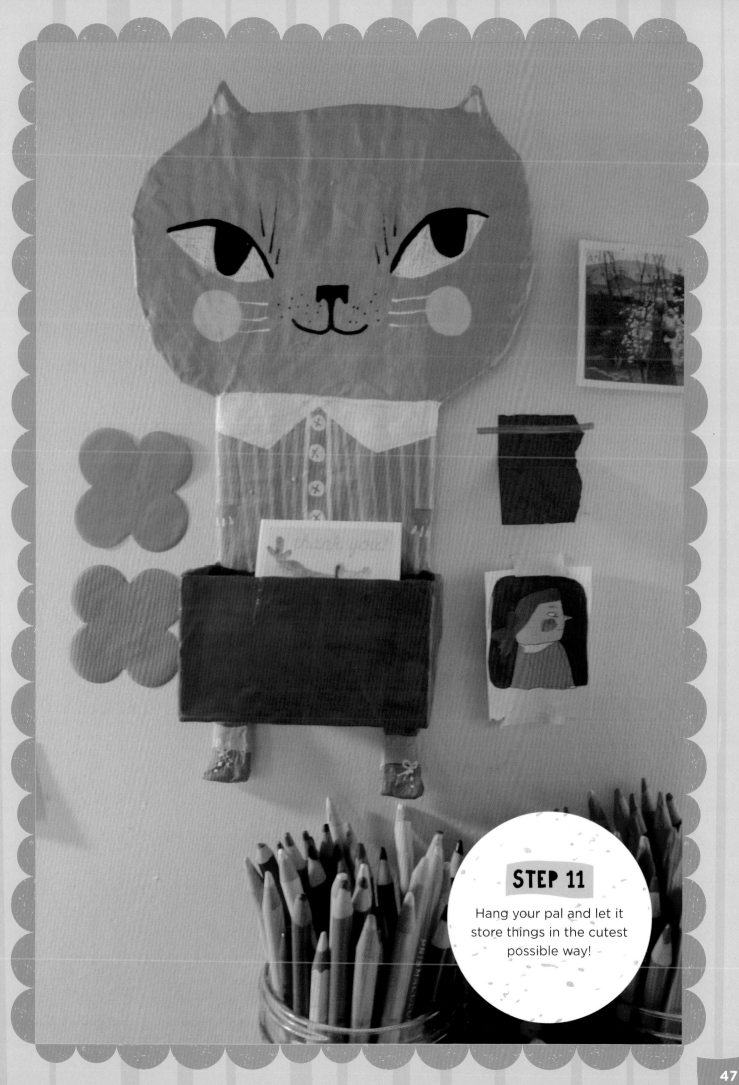

Robin

Whether you make a realistic-looking bird or something more fanciful, a papier-mâché bird will look amazing perched in your home. These are quite addicting to make, so be warned: You may end up with an entire flock!

TOOLS & MATERIALS

- Packing paper or newspaper
- Masking tape
- Hot-glue gun
- Aluminum foil
- Scissors
- Thin cardboard
- 18- to 20-gauge floral wire
- Pliers
- Paste
- Sandpaper
- Gesso
- Paint and paint pens
- Sealer

STEP 1

Pick a bird from nature or your imagination that you'd like to recreate. Then crumple up some paper to form the shape of the bird's body. Cover the bird with masking tape, ensuring that it keeps its shape.

STEP 2

Use the same method to create the bird's head. As you shape the head, use the bird's body for reference and shape the head until it looks proportionate with the body. Then tape it securely.

Hot glue the bird's head to the body to hold them in place.

STEP 3

Use at least four vertical strips of tape to attach the bird's head to the body. Then add tape around the neck to form a strong, smooth attachment.

STEP 4

Pinch and squish a small piece of foil into a beak shape. If you make it too big at first, just uncrumple the foil and tear away some of it; then redo the beak until it is the right size.

STEP 5

On a hard surface, such as a table, rub the base of the beak to smooth and flatten. This creates a good surface for gluing the beak to the head in the next step.

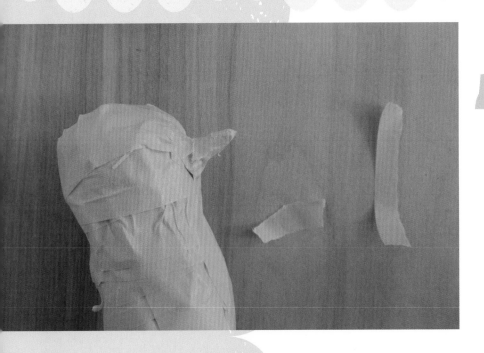

STEP 6

Hot glue the beak to the bird's head; then add tape over the beak.

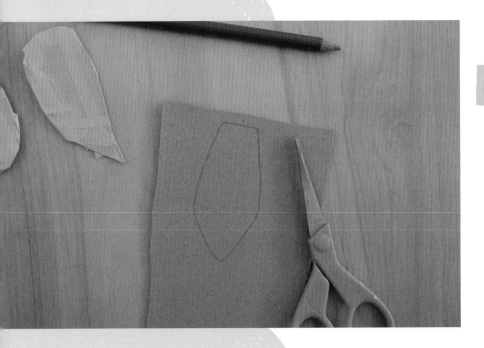

STEP 7

Cut a tail feather from thin cardboard—any triangular shape works.

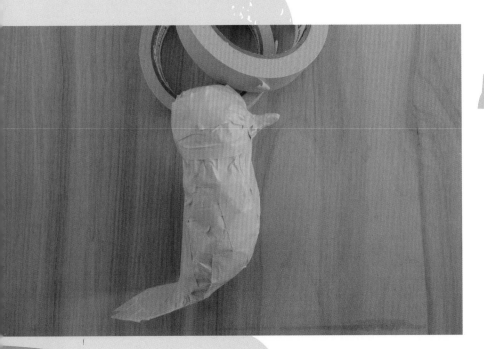

STEP 8

Hot glue the tail feather to the bird. Gluing it under the end of the body ensures that it flips upward in a sassy way!

Then tape the tail feather and the spot where it attaches to the body to smoothly join the two.

STEP 9

Draw a wing on thin cardboard and cut it out. Then trace that wing onto another piece of cardboard and cut it out so that the wings are identical.

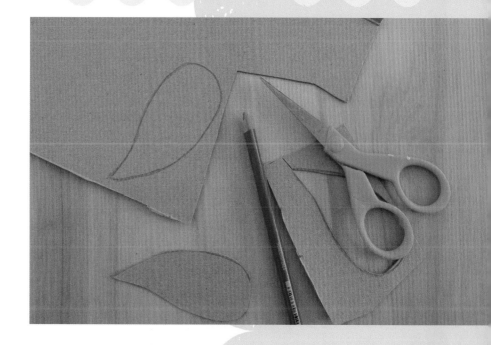

STEP 10

Cover the wings with tape.

STEP 11

Apply hot glue to the top third of each wing and place both wings on the bird's body, as shown. This lets the wings stand away from the body a little bit, which looks adorable!

STEP 12

Each bird leg will consist of four pieces of wire. Tape the wires in a little bundle, leaving about ¾ inch free on one end for the toes. Make two legs. How long should they be? It's your choice, but keep in mind that you'll need ¾ inch for the bird toes at one end and 1 inch at the top to glue to the body.

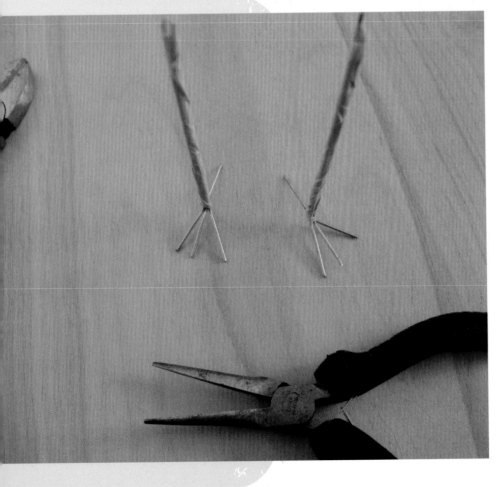

STEP 13

Use pliers to bend the wire out for the toes—three in front and one in back.

Set the legs aside. You will papier-mâché the legs and body separately and attach the legs to the bird when everything is dry.

STEP 14

Make paste and tear up paper. Using a long strip of paper dipped in paste, wrap each bird leg starting just above the toes, all the way to the top of the leg. Then papier-mâché the beak and the unattached parts of the wings. Wrap the paper around the wing, all the way up to where it is glued down. It's helpful to get these parts done first, as they are the most complex. Then papier-mâché the rest of the bird.

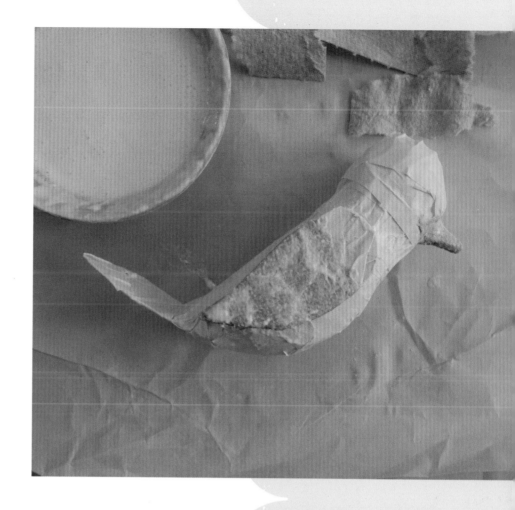

STEP 15

Let the papier-mâché dry; then sand the bird.

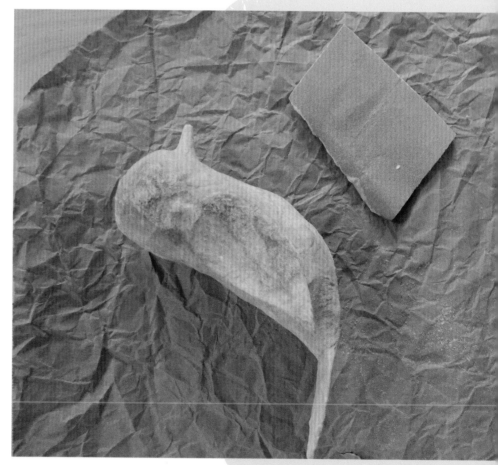

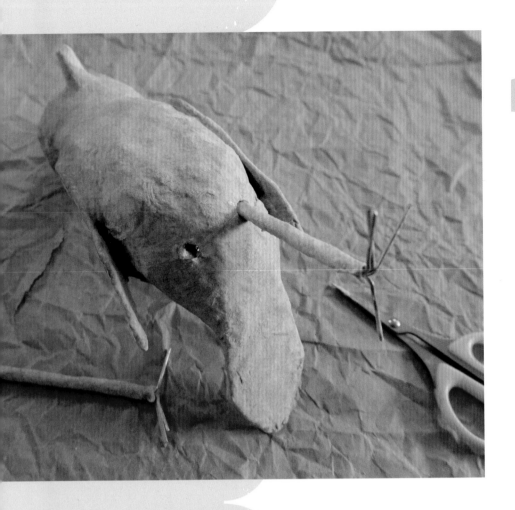

STEP 16

To attach the legs, use pointy scissors to make two holes in the underbelly of the bird. Don't worry—he can't feel it! Make the holes toward the middle back, leaving about 1 inch or so between them. Add a little hot glue in the holes and stick the legs in, feet forward!

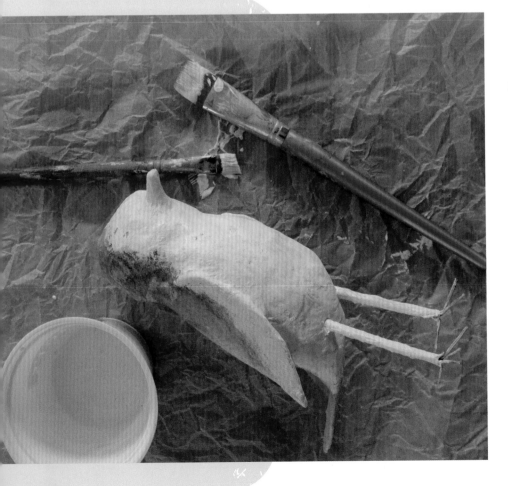

STEP 17

Gesso the whole bird. Make sure to get under the wings!

STEP 18

Painting birds is so much fun! The multiple steps and layers take a bit of time, but the results are worth it.

First, paint the base colors. Let them dry. Then paint the beak and add feathers. Light dabs and lines with a small brush make lovely feather textures. Layer until you're happy.

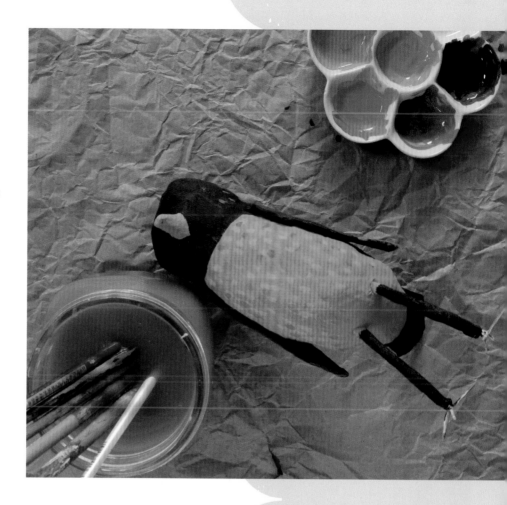

STEP 19

Check that your bird is balanced and has a solid stance. Adjust the toe wires if necessary.

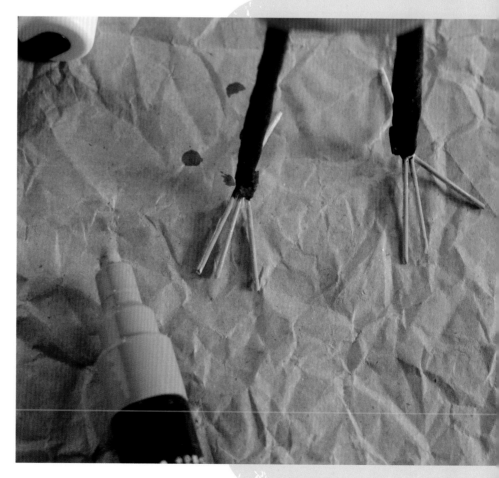

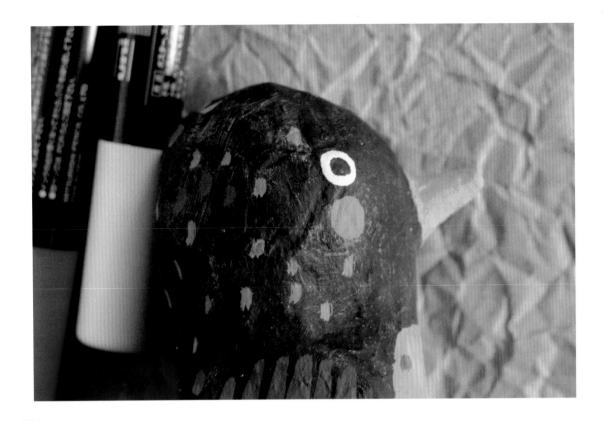

STEP 20

Add the eyes using paint markers for better control. I also added red cheeks because I love the way they look. Let dry completely.

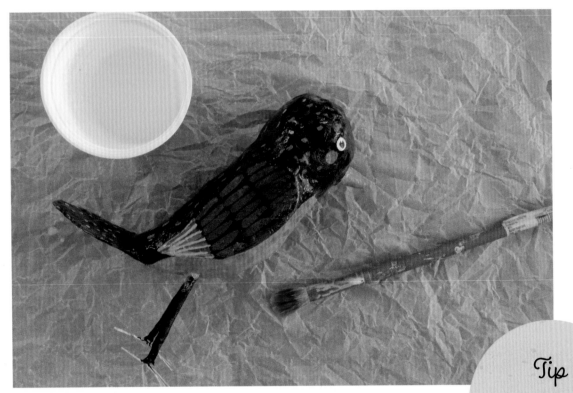

STEP 21

Seal and let dry.

Tip

I like to use a paint marker to paint the toe wires.

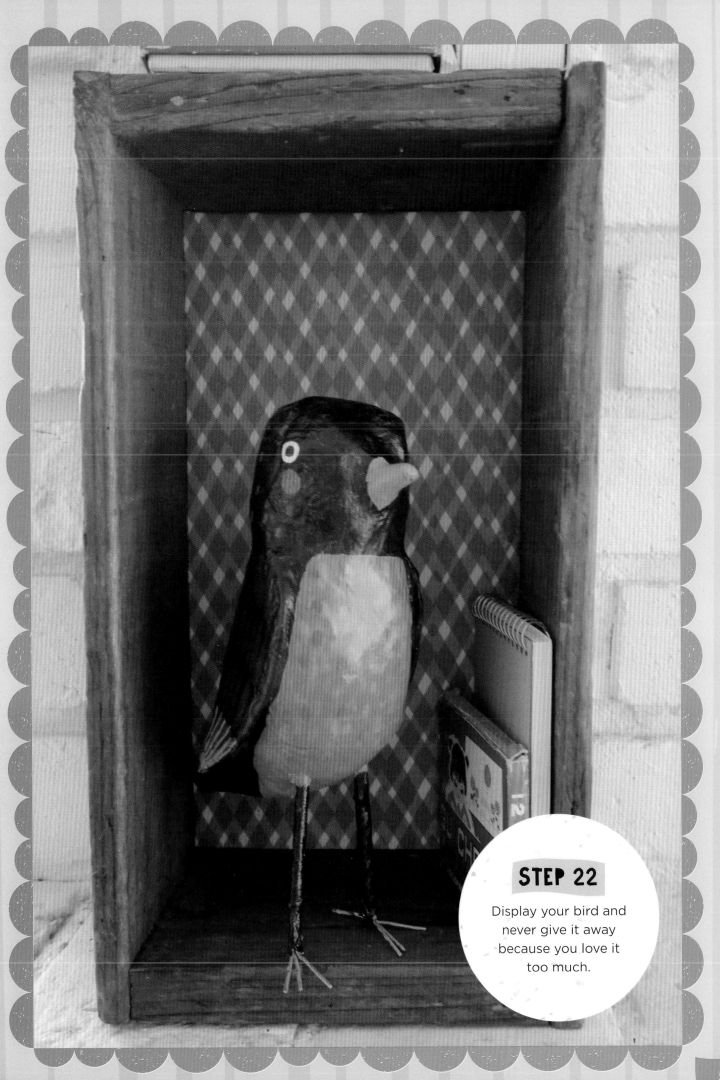

STEP 22

Display your bird and never give it away because you love it too much.

Giant Ice-Cream Cones

Do we need giant ice-cream cones? Probably not. But do we want them? Yes! This is a completely frivolous project—but also utterly wonderful. I love the paint possibilities with ice cream. You can paint sprinkles, various flavors, and so on.

Ice cream is fun to start with, but using the techniques in this book, you can also make your own favorite food in a giant size. My students have made giant cheeseburgers, a huge taco with a mustache, a massive cupcake, an extra-large bottle of hot sauce. What larger-than-life food would *you* like to make?

TOOLS & MATERIALS

- Large piece of cardboard, such as the side of a box
- Craft knife and scissors
- Hot-glue gun
- Masking tape
- Plastic grocery bag

- Recyclable items, such as newspaper, bubble wrap, and paper
- Paper
- Paste
- Gesso

- Paint
- Glue
- Sealer
- Optional: sandpaper
- Optional: construction paper

STEP 1

Draw a curved line on the piece of cardboard, as shown. I've used a 17" x 19" piece of cardboard, but any size will work.

STEP 2

Cut away the excess cardboard.

STEP 3

Roll the cardboard back and forth a bit to make it flexible.

STEP 4

Curve the cardboard into a cone shape. This might be tough, but go ahead and beat up the cardboard to get it really flexible.

Once you have the right shape with a 1-inch overlap, run a bead of hot glue along the length of the seam and carefully hold it together until it dries.

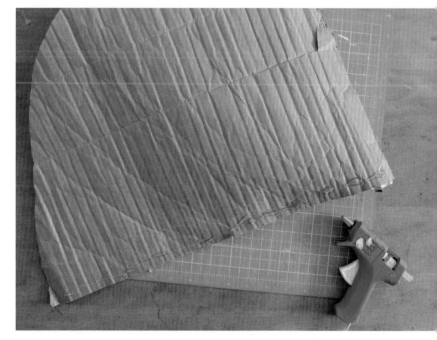

STEP 5

Reinforce the seam with tape, as shown.

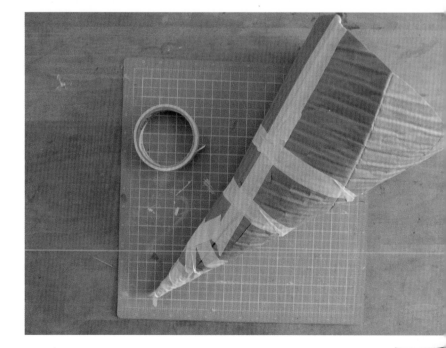

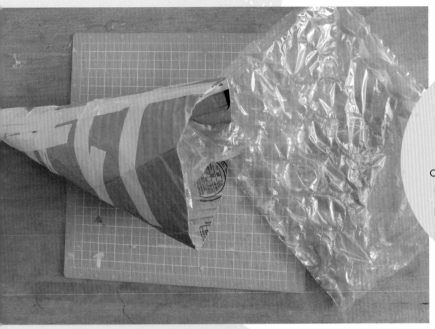

Tip

If you want to bulk up the shape of the ice-cream cone, stuff it. I've used bubble wrap and plastic shopping bags.

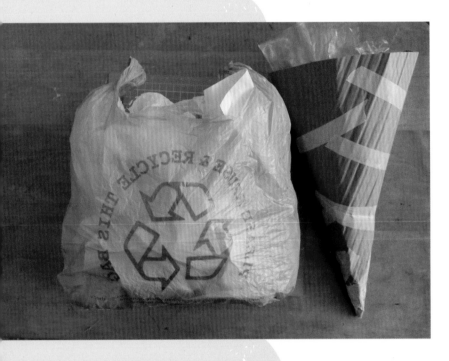

STEP 6

Now make the ice cream! You can make as many scoops as you like. Fill the plastic grocery bag with recyclable items, such as plastic bags, bubble wrap, crumpled paper, and so on. Make the bag very full, as you'll crumple it down a bit when you add tape.

STEP 7

Tape the handles of the bag together to close it. My bag has a distinctive scoop shape, which I like, so I've kept it that way. If you want a rounder shape, squash and mold it with your hands, and then add tape.

STEP 8

Tape the bag. Instead of fully encasing it, I recommend keeping space between the strips of tape.

Then add long strips of tape from the top of the bag/scoop to the cone to attach the scoop to the cone. Don't pull the tape too tight to avoid distorting the scoop shape.

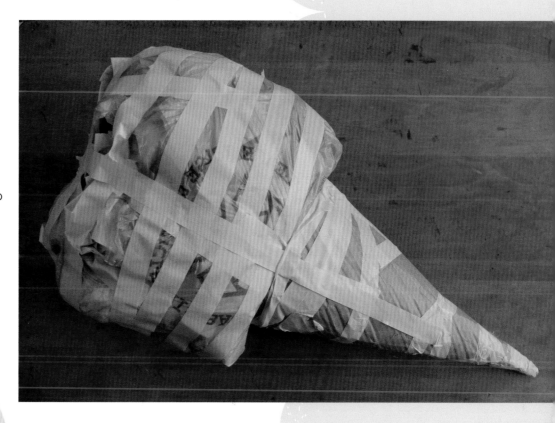

Tip

If you are making multiple scoops of ice cream, use long pieces of tape to attach them as you build up the cone.

STEP 9

If your ice cream will feature a face, like mine, make a nose out of a bit of crumpled tape and place it on the scoop.

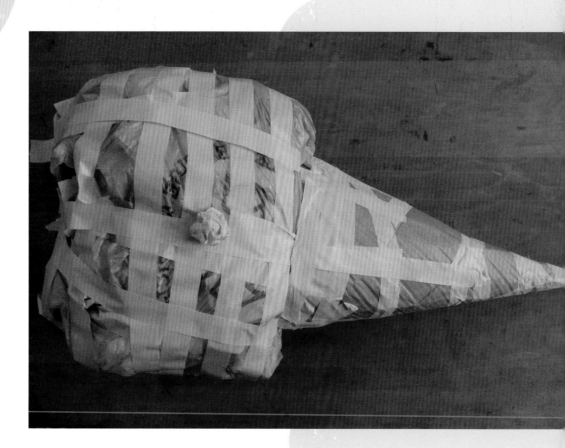

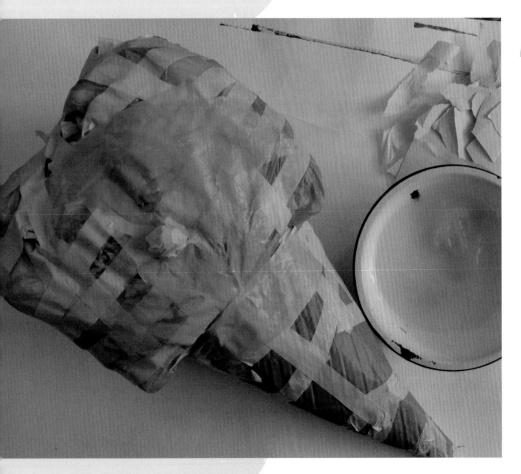

STEP 10

It's papier-mâché time! Because this is a large sculpture, you will need to use big pieces of paper to cover it. Tear your preferred paper. I've used packing paper, but paper bags also make a great choice.

Now make your preferred paste; I've used cornstarch.

Then papier-mâché that ice-cream cone! The size might make this awkward, so if you prefer, papier-mâché one side at a time, letting the sculpture dry between sides. Use at least two layers of papier-mâché—or more if preferred.

Let everything dry; then sand down the sculpture, if you like.

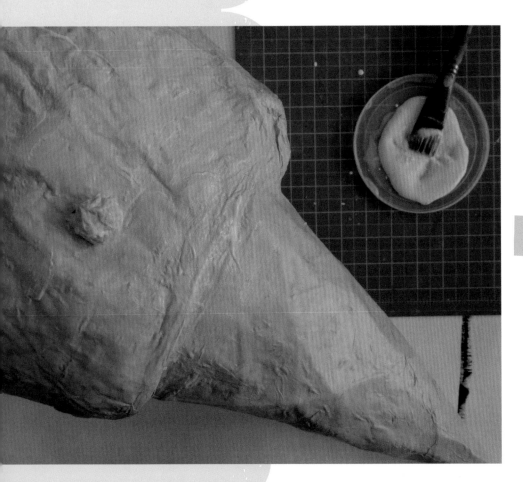

STEP 11

Gesso and let it dry. You can set the sculpture in front of a fan to speed up the drying process.

STEP 12

Add paint! I've started with a waffle pattern on the cone consisting of light and dark brown. Paint the cone first so that the paint on the ice-cream cone can drip down the cone. Let the paint dry.

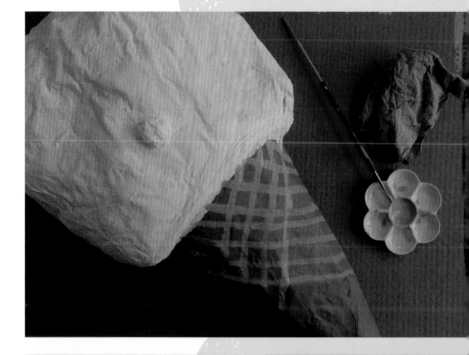

STEP 13

Pick your ice-cream flavor. Is it a real flavor or one that you've created from your imagination? Are there chunks of fruit, cookies, or chocolate chips in it? Paint the base color first, and add details and flavors afterward.

STEP 14

If your cone will have a face, add it now. Let the paint dry completely.

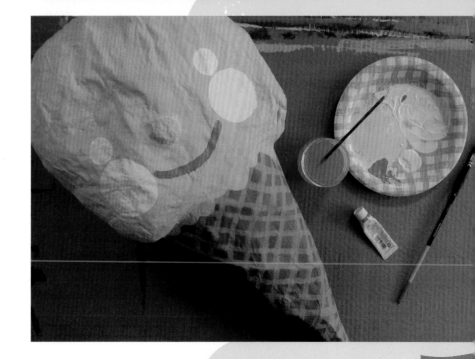

STEP 15

To add sprinkles, I started with a single hole punch and made lots of small, round sprinkles. After putting them on the scoop, I decided I wanted something a bit bolder, so I've used a paper shredder to make strips of colored paper. I've snipped them down to sprinkle size.

Brush a coat of white glue or Mod Podge Hard Coat on the top of the scoop, and then add as many sprinkles as you like! Let the glue dry, and then seal with the sealer of your choice, if you wish.

Tip

Instead of sprinkles, consider adding a hot-fudge toupee!

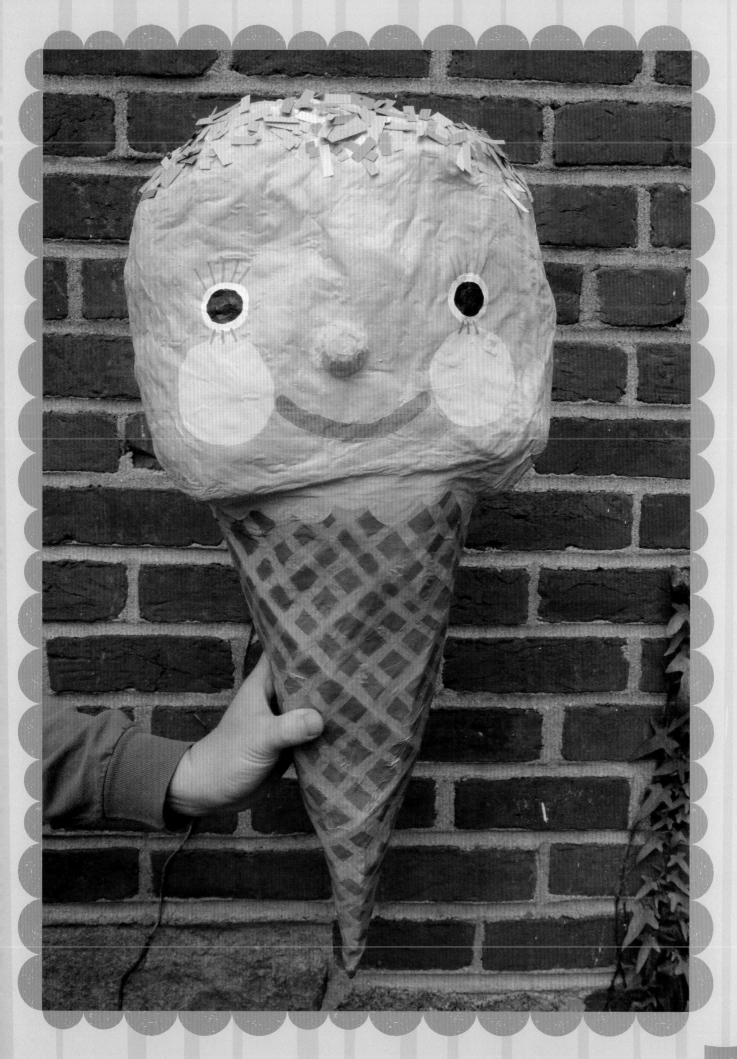

Holiday & Everyday Ornaments

Ornaments are just tiny sculptures as far as I'm concerned! And they aren't only for decorating trees; I love to add a funny personalized ornament to gifts too.

You can make these ornaments with a theme in mind: animals, family members, fruits, veggies...you name it! I'll walk you through how to make a Pembroke Welsh Corgi, but feel free to use these techniques to make ideas of your own. I've included a few other ornaments as inspiration.

Tip

These sculptures are small, so keep the details simple or adding papier-mâché to them will be very frustrating!

TOOLS & MATERIALS

- Aluminum foil
- Hot-glue gun
- Chipboard
- Masking tape
- Paste

- Paper
- Sandpaper
- Scissors
- Gesso
- Wire and wire cutter

- Pliers
- Awl or thick needle
- Paint pens
- Sealer
- Pipe cleaners

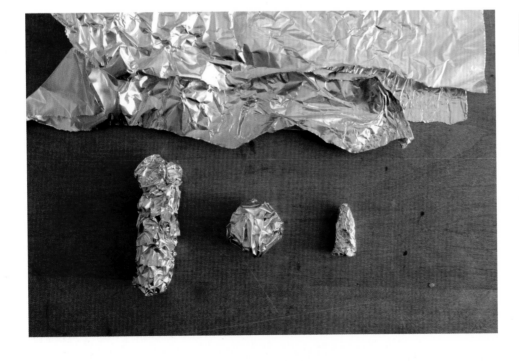

STEP 1

Decide what you want to make. I'm making a Corgi because I adore them, but this tutorial will work for almost any pet or four-legged animal!

Using small bits of foil, make a body—sort of a tube-ish blob. You don't want realistic anatomy here; the simpler, the more fun these things are. Make a round head and a pointy snout.

STEP 2

Hot glue the snout to the head and the head to the body.

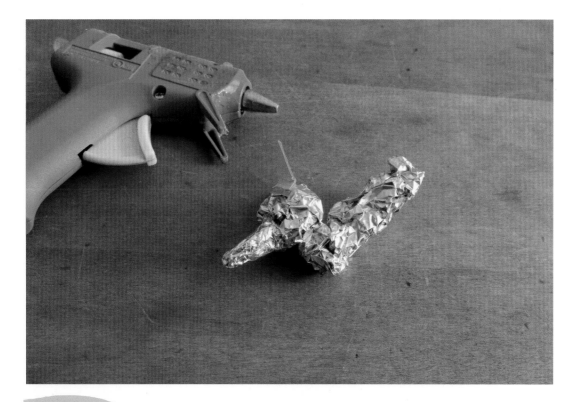

STEP 3

Draw pointy ears on chipboard, including an approximately ¼-inch tab at the bottom where you will add glue. Cut out the ears and fold along the lines you added at the bottom. Hot glue the ears to the Corgi's head.

STEP 4

Cover the entire ornament with masking tape.

Shown here are some other ornaments I made using the foil-and-hot-glue method: an apple, a peanut, and a bunny!

STEP 5

Make paste using flour and water, and tear up your paper (any kind you like; shop towels are great because they are thick enough that you will only need one layer). Then papier-mâché your ornament.

STEP 6

Let your ornament dry, or to bake it in the oven, place it on a parchment-covered cookie sheet, bake for about an hour at 170 degrees Celsius/340 degrees Fahrenheit, turning halfway through. Make sure to check on the ornament while baking.

STEP 7

Sand off any crusted glue or bits that poke out.

STEP 8

To make holes for adding pipe-cleaner legs, use very pointy scissors and carefully poke four holes where the legs should go. The holes need to be big enough for pipe cleaners, but not much larger than that.

STEP 9

Gesso your ornament.

STEP 10

To make the hanging loop, cut a small piece of wire (about 1½ inches). Bend the wire in half, and then crimp the two cut ends by squeezing them together with pliers. Then, using an awl or a thick needle, make a hole for the hanging loop.

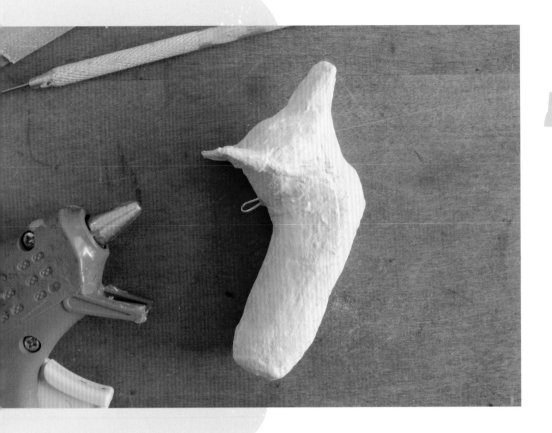

STEP 11

Add a bit of hot glue to the hole and press the ends of the wire loop in. Immediately wipe off any hot glue that collects at the base of the loop.

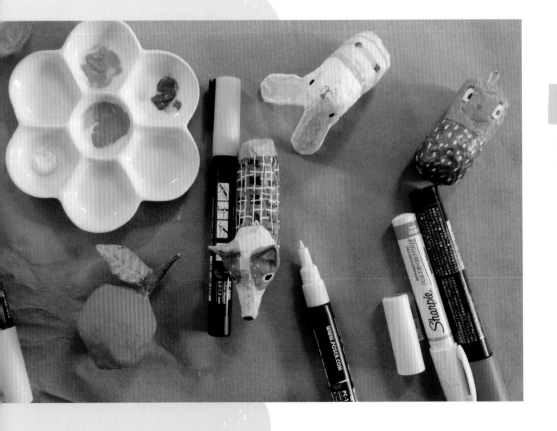

STEP 12

Paint your little buddies and add details with paint pens. Indulge in details here—these are small pieces and they're quick to decorate. They look great in bright colors, and everything I make gets a face!

STEP 13

Seal and let dry.

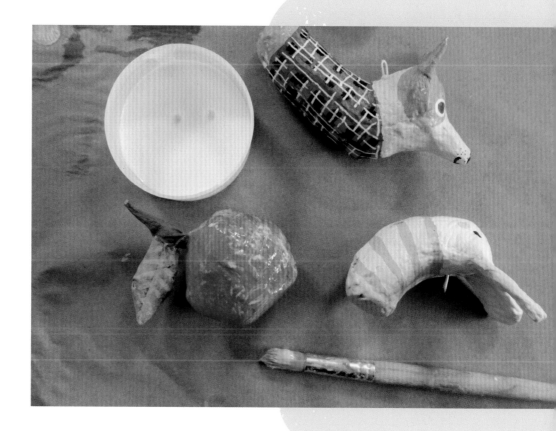

STEP 14

Now let's add some legs. Cut your pipe cleaner legs to any length you like. I love bending a little foot too. Add a bit of hot glue to each hole and stick the legs in.

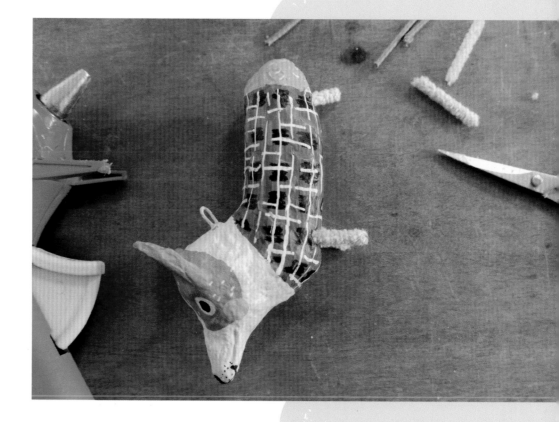

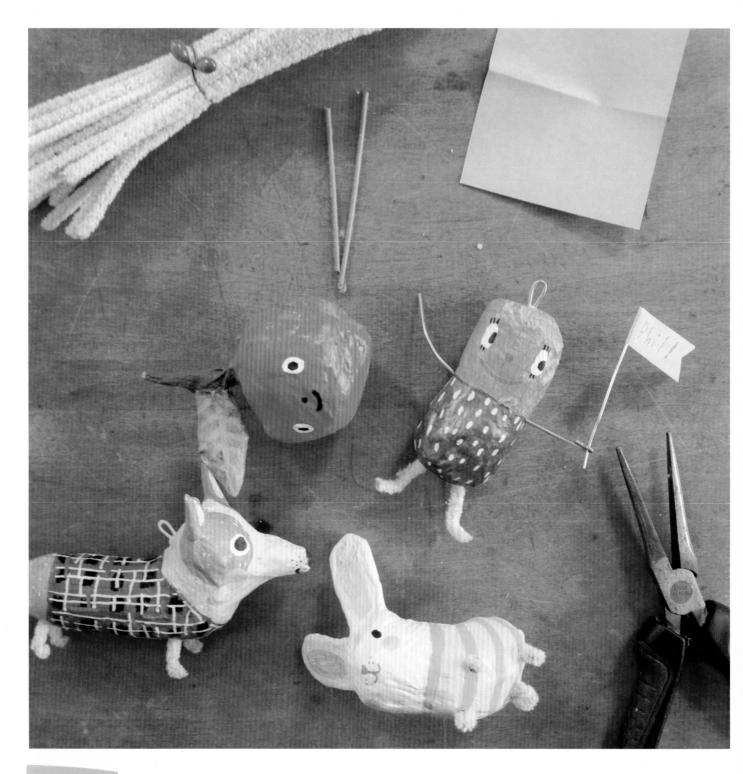

STEP 15

My other ornaments have various bits of wire for arms and legs too. Use whatever you happen to have on hand. To personalize your ornament, you can use the flag-making technique from the "Your Biggest Fan" project (pages 96-97) and add a name to it.

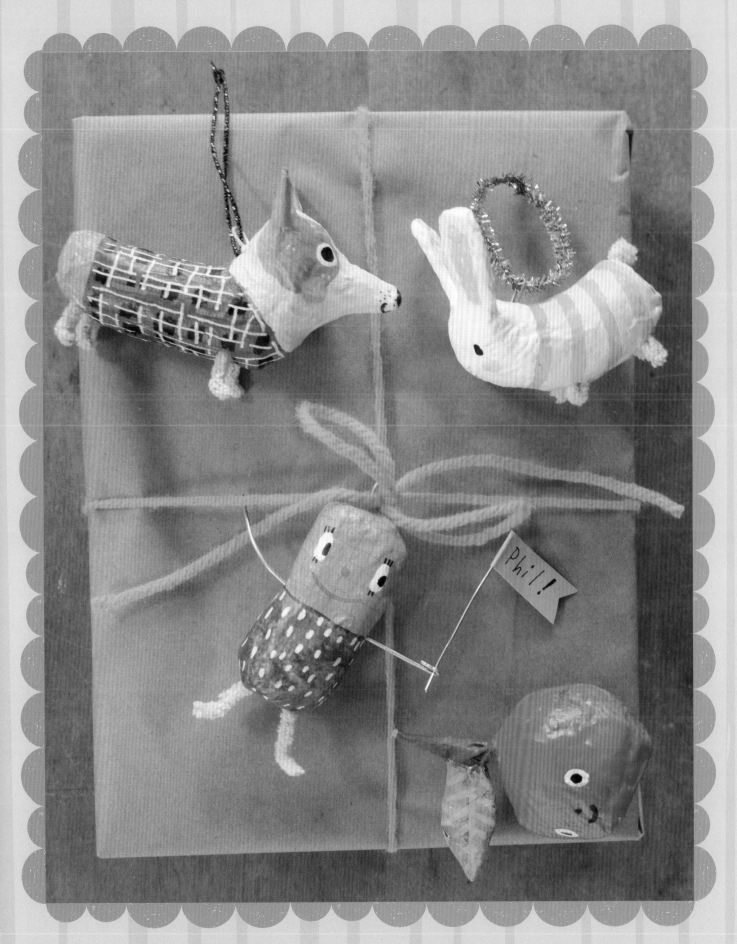

Look at these fun friends! You can tie string or ribbon loops for hanging, or use your homemade ornaments as a gift topper. I can't think of anything that wouldn't be better with an ornament added to it!

Pet Portrait

This project is a bit more complicated and requires some planning, but it's well worth the extra effort. Follow the steps and take your time, and you will have a perfect masterpiece of your pet, already framed! You can even try making a whole portrait wall of your pets. You won't want to stop at just one!

TOOLS & MATERIALS

- Wooden plaque of any size and shape
- Two pieces of corrugated cardboard or foam-core board (these should be larger than the wooden plaque)

- Ruler
- Pencil
- Craft knife
- Hot-glue gun
- Masking tape
- Aluminum foil
- Paste

- Paper
- Parchment paper
- Sandpaper
- Gesso
- Paint
- Sealer

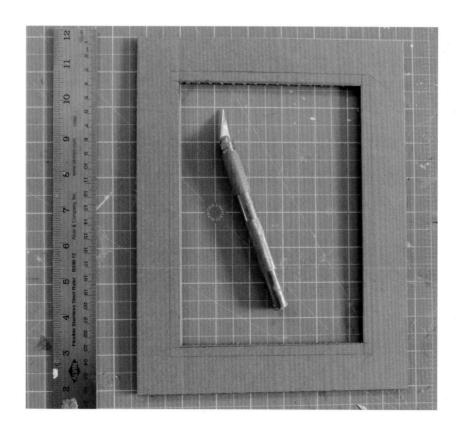

STEP 1

You will need to make two layers for this project: a base layer consisting of a frame and your pet, as well as another frame on top.

For the top layer, trace around the wooden plaque onto the cardboard. Then use a ruler to measure ¼ inch in all the way around, and mark the lines with a pencil. This is the margin where the frame will overlap with the edges of the board.

Now measure 1 inch out from the traced line all the way around, following the shape. Connect the marks.

Cut out the inside section first; then cut around the outside.

STEP 2

To form the base layer, trace the inside and outside of the frame you cut out in step 1. Then draw your little buddy inside the frame you drew, keeping some space around the pet.

Cut around the pet and remove the extra piece of cardboard.

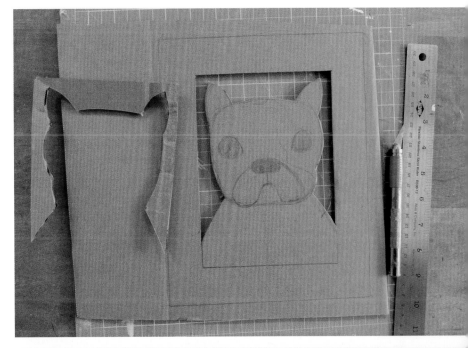

STEP 3

Hot glue the base layer of cardboard (the frame and the pet) to the wooden plaque. Press down until the glue is set.

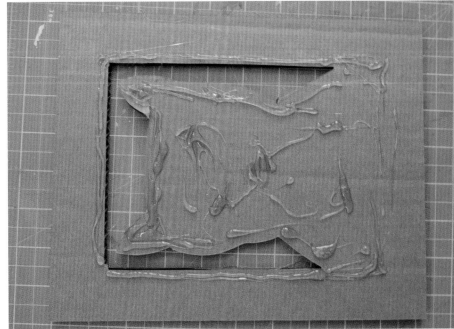

STEP 4

Hot glue the back of the top frame; then line it up with the inner frame and hold until set.

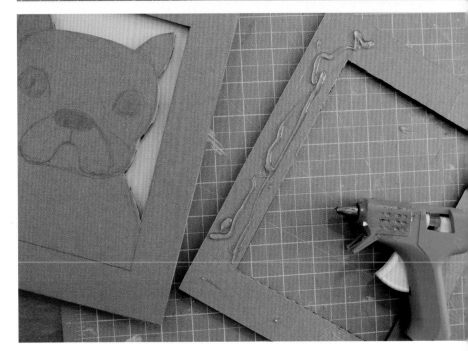

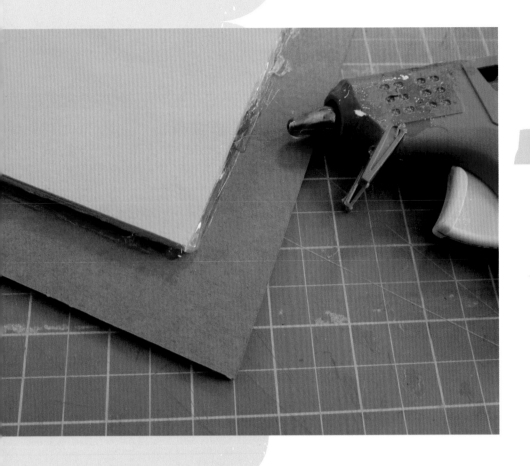

STEP 5

Use the hot glue gun to "caulk" and seal any gaps between the frame and the board.

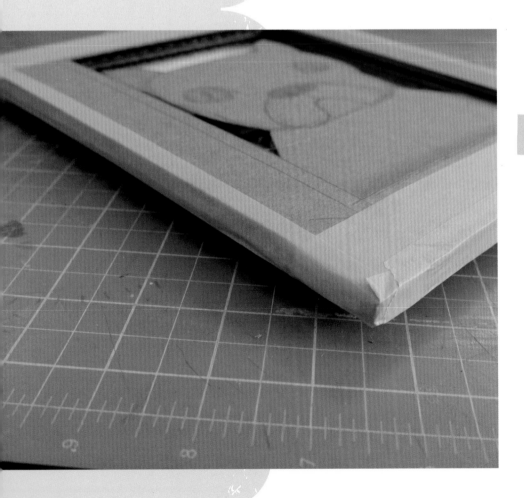

STEP 6

Apply tape to seal the edges of the frame and around where the cardboard is glued to the plaque on the back.

STEP 7

To give your portrait a bit of dimension, create a little nose made from foil. Use hot glue to attach it and place tape over it.

Tip

Use the point of a pencil to wedge the papier-mâché into tight spots if necessary.

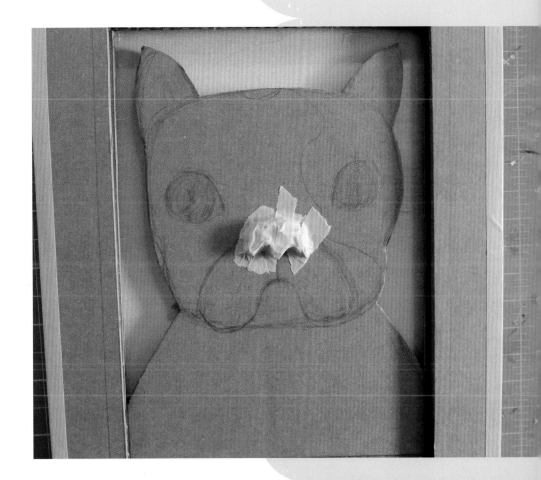

STEP 8

Prepare your paste and paper. Then apply at least two layers of papier-mâché to the portrait, making sure to encase the outer edges of the frame and the edges of the plaque on the back.

Place the portrait on parchment paper and dry in the oven for about 1 hour.

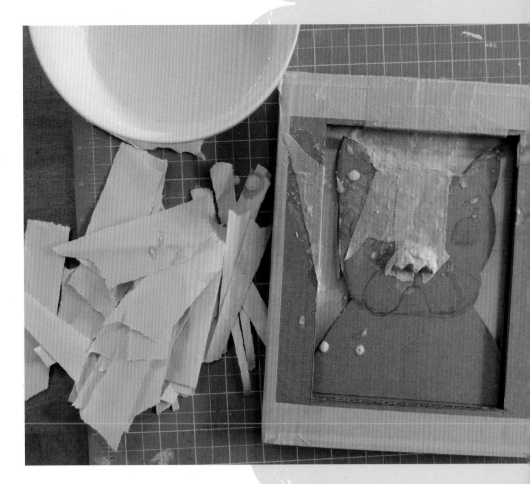

STEP 9

Gently sand off any wrinkles, folds, and paste on the back of the portrait.

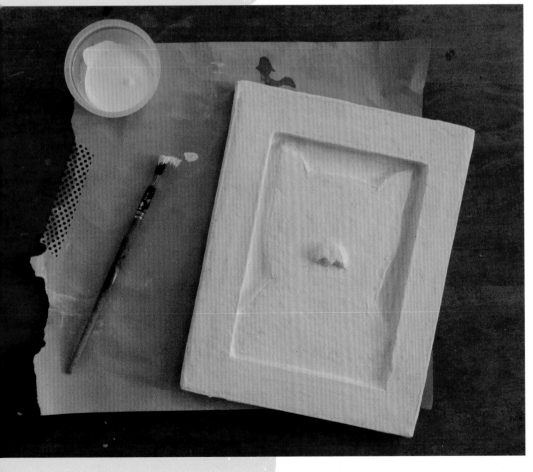

STEP 10

Thoroughly apply gesso, working on one side at a time and letting it dry completely.

STEP 11

Draw your pet again on the papier-mâché shape, blocking in where you want to place the main colors in the image.

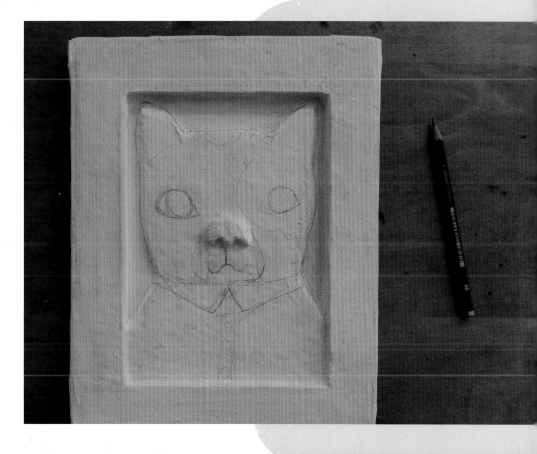

STEP 12

Now add paint, starting with the background. Let it dry.

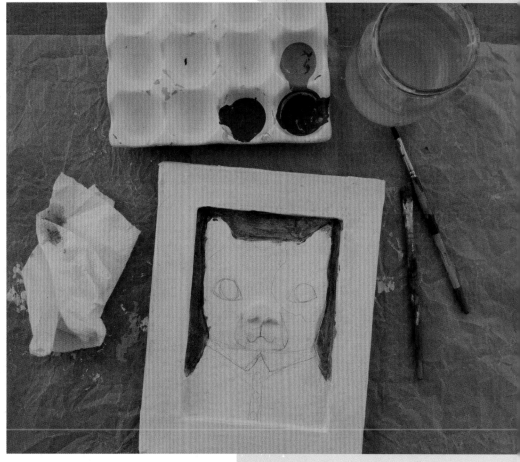

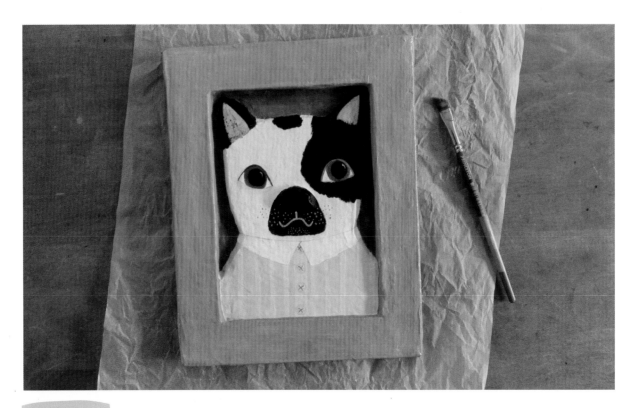

STEP 13

Now paint your pet using a reference photo if you like. Include details to bring your friend to life, such as whiskers, fur texture, and clothes. Then let the paint dry completely.

STEP 14

Paint the back of the piece as well!

Once the paint is completely dry, use any sealer that you life. I've kept the portrait matte except for a glossy finish on the nose and frame.

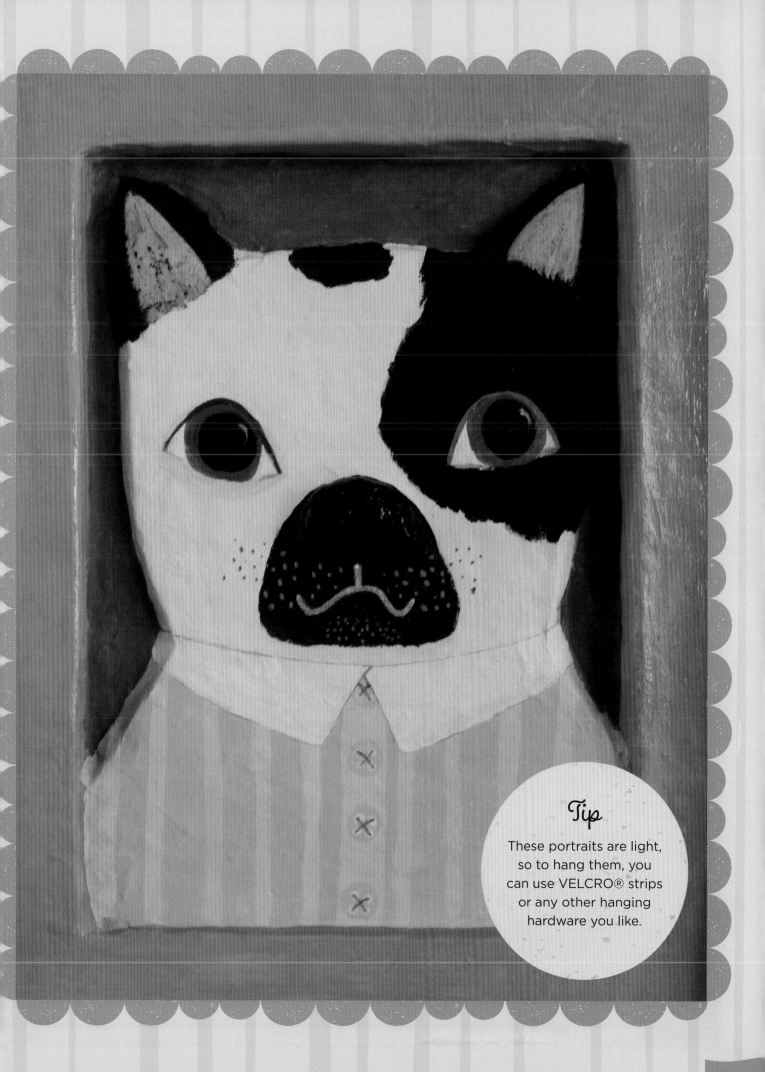

Tip

These portraits are light, so to hang them, you can use VELCRO® strips or any other hanging hardware you like.

Birds on a String

This project was inspired by strings of sewn fabric birds that I've always admired. These look super sweet hanging in a little corner that needs brightening up, and adding a bell and beads makes this a lovely decoration or gift. It's a simple project but one that will take a bit of time since you'll need to make multiple birds. Work on this project over a few days and it will come together beautifully.

TOOLS & MATERIALS

- Corrugated cardboard
- Wire
- Aluminum foil
- Masking tape
- Hot-glue gun
- Paste
- Paper (I like shop towels)
- Sandpaper
- Gesso
- Paint
- Sealer
- Pliers
- Waxed thread
- Bells and beads
- Embroidery needle

STEP 1

Use corrugated cardboard to make a template for your birds. Keep it simple—we're looking for the idea of a bird rather than lots of realistic detail.

Trace the template onto the cardboard as many times as you like. I made seven birds. Make sure the lines on the cardboard are vertical so that you can do the next step.

STEP 2

Place a piece of wire through the middle of each cardboard bird shape. Using the tunnels that are built into corrugated cardboard makes this simple. This will help later when you string the birds together.

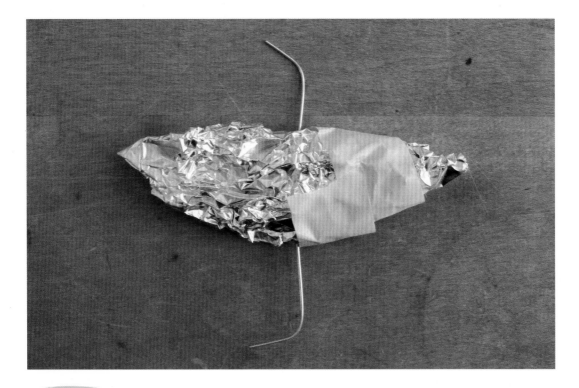

STEP 3

Pad the sides of the bird shapes with crumpled-up bits of foil until the birds look a little chunky. How full you make them is up to you! Attach the foil using masking tape.

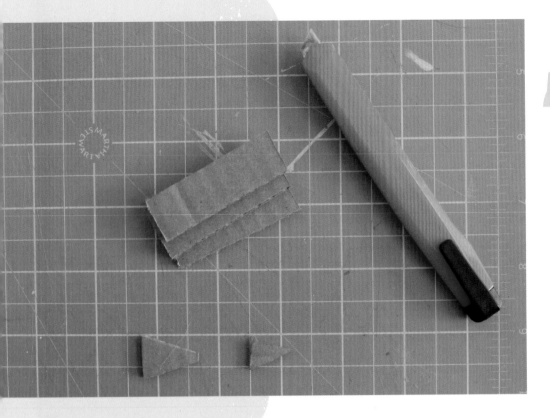

STEP 4

Now make beaks and tail feathers using cardboard. This is a great way to use up any scraps of cardboard you have leftover from the previous step. For the beak, I cut out a small triangle. For the tail, I cut out a larger triangle and snipped off the top point. To give the birds their own personalities, you can eyeball this so that each bird looks a little different.

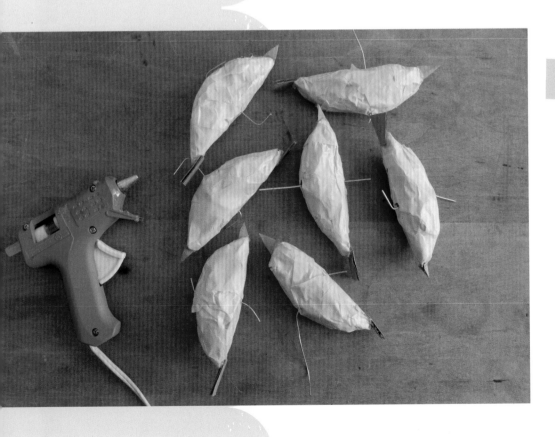

STEP 5

Hot glue the beaks and tails to the birds, and add tape.

STEP 6

Make paste using flour and water, and tear up shop towels. They work best for this project because they can quickly build up a thick layer. Then papier-mâché the birds using a light touch on the beak to maintain its point.

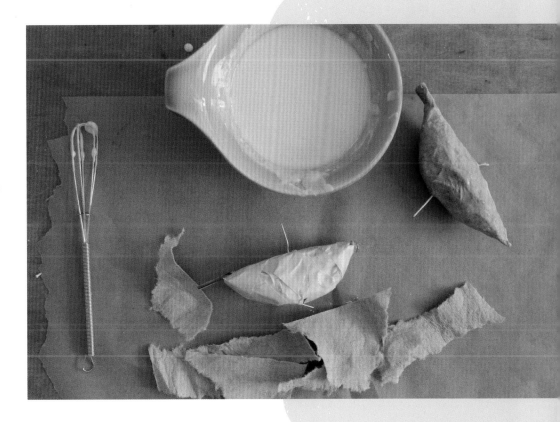

STEP 7

Let the birds dry in front of a fan or in the oven. I like to put parchment paper on a cookie sheet and line up my birds and bake them for about an hour at 170 degrees Celsius/ 340 degrees Fahrenheit. Flip halfway through baking so that the birds dry on all sides. Keep an eye on your birds during baking—you don't want to scorch them! Then sand off any rough spots.

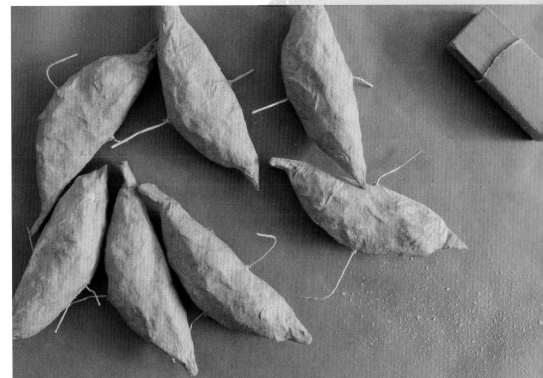

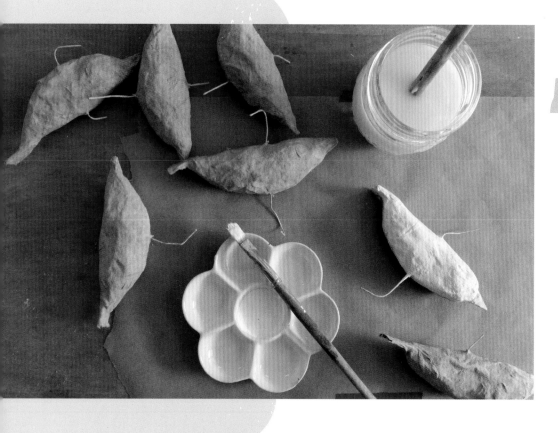

STEP 8

Gesso the birds and let them dry. Keep the wires in the birds!

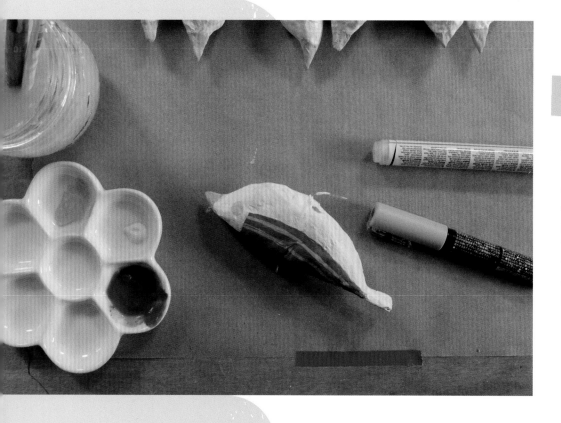

STEP 9

Paint your birds. You've got so many options here: rainbow, monochrome, ombré... You can paint them any way you like. I painted mine using greenish-blue tones. Make sure to paint wings on each bird. Add eyes, and don't forget to paint the beaks too!

STEP 10

Once the paint is fully dry, seal the birds. I used a satin finish. Let dry completely.

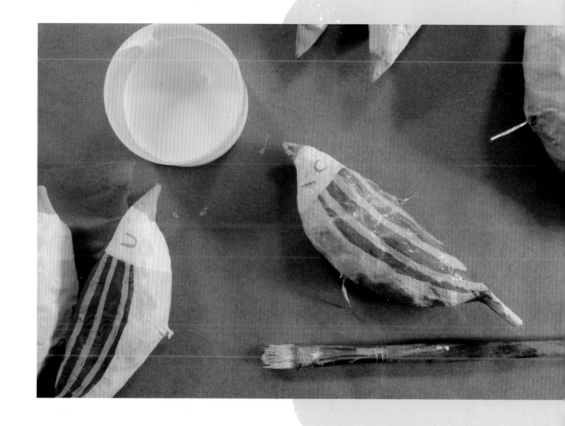

STEP 11

It's time to remove the wires! Jiggle them a little in case any paste, paint, or sealer has the wires stuck; then gently remove them. Using a pair of pliers to grip the wire may make this easier.

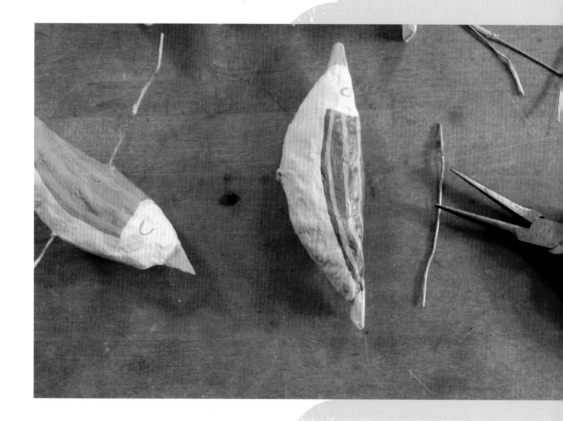

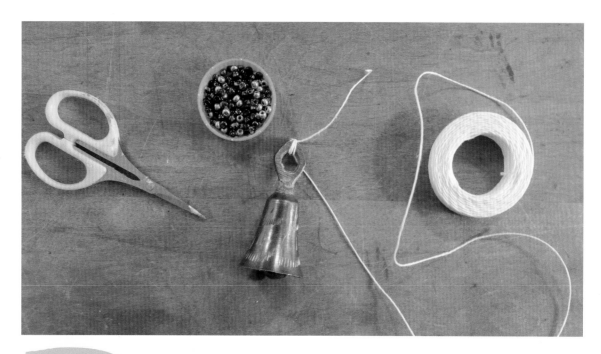

STEP 12

Now we string them! Get a long piece of strong thread. I've used waxed linen thread because it's strong, not slippery, and easy to string beads onto without a needle.

Start at the bottom and tie your bell securely.

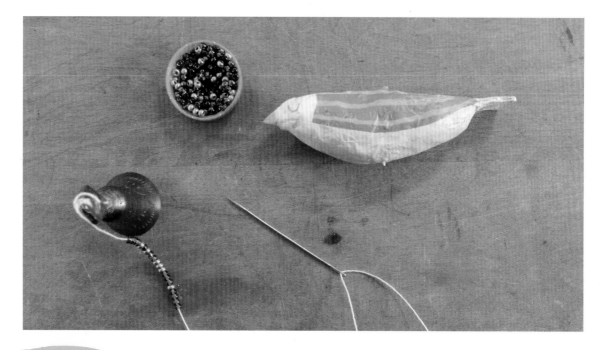

STEP 13

Thread the beads onto the waxed thread. To create even spacing, use the same number of beads between each bird. (I used 20.)

Now add a bird. Thread a large embroidery needle onto your string and guide it through the bird using the channel you created with the wires, bottom to top. Remove the needle.

Add beads to your waxed string. Continue stringing each bird and the beads until you've added all of the birds. Add one last layer of beads too!

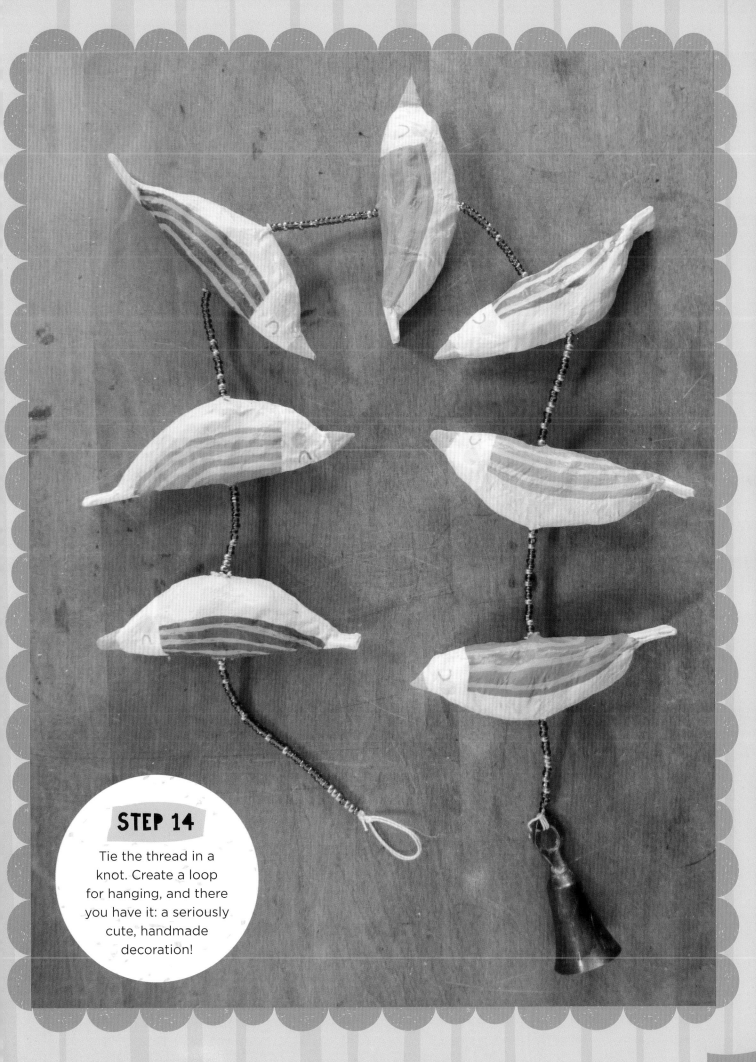

STEP 14

Tie the thread in a knot. Create a loop for hanging, and there you have it: a seriously cute, handmade decoration!

Your Biggest Fan

Sometimes you need a little extra encouragement, so why not make your own portable fan? This little buddy will always know what to say to lift your spirits.

TOOLS & MATERIALS

- Aluminum foil
- Masking tape
- Scissors
- Hot-glue gun
- Dowels
- Paper (I like shop towels)
- Paste

- Sandpaper
- Gesso
- Paint and paint pens
- Sealer
- Pipe cleaner
- Round slice of wood
- Drill

- Paper
- Wire
- Glue
- Binder clip
- Pliers
- Optional: tiny stamps

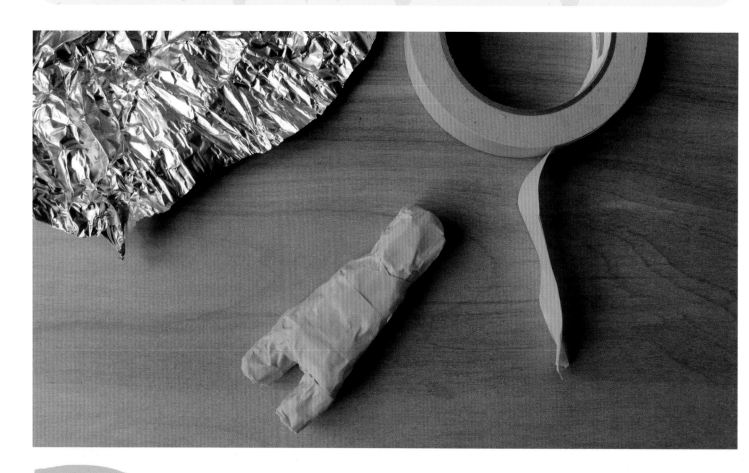

STEP 1

Sculpt a small (around 5 inches tall) figure out of aluminum foil. Cover it with masking tape.

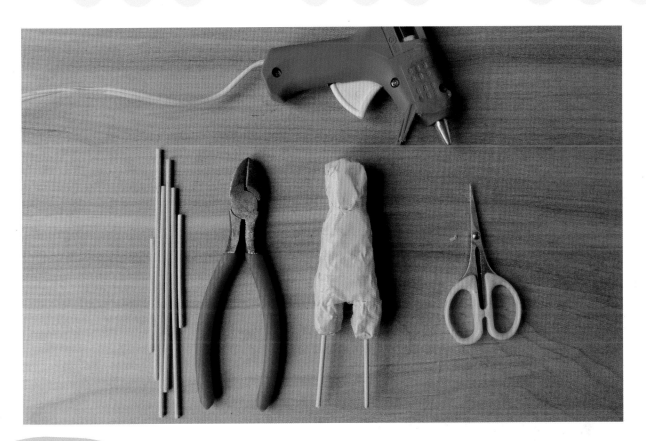

STEP 2

Poke holes for the legs (I like to use small, sharp scissors), and hot glue dowels in them.

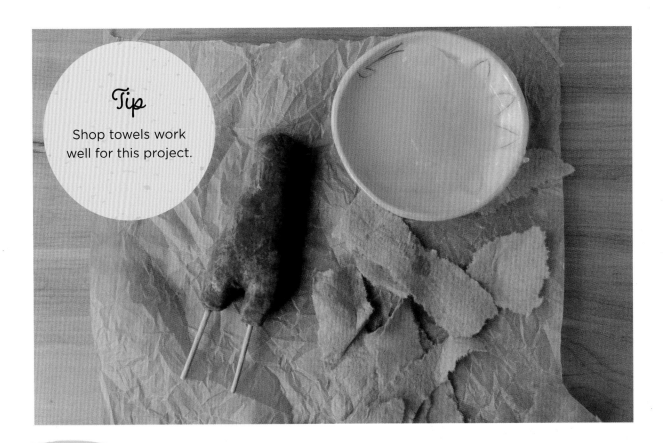

Tip

Shop towels work well for this project.

STEP 3

Cover the whole figure with two layers of papier-mâché. Let it dry.

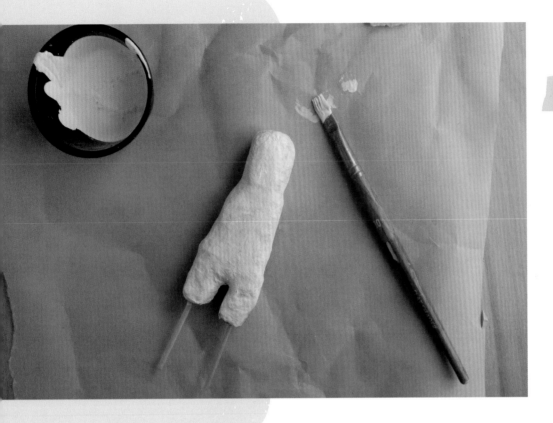

STEP 4

Lightly sand and gesso the entire figure, including the legs if you plan to paint them.

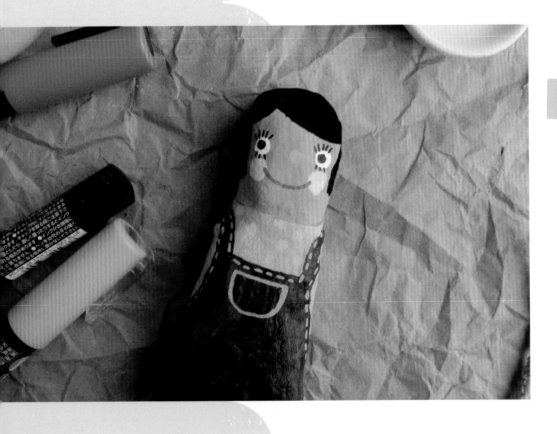

STEP 5

Paint your pal and add details with paint pens, taking your time with the small details. Seal the figure.

STEP 6

Paint a cotton pipe cleaner (see page 10) the same color as the shirt of your pal. The pipe cleaner will form the arms.

STEP 7

Mark where the legs will go on the wooden stand.

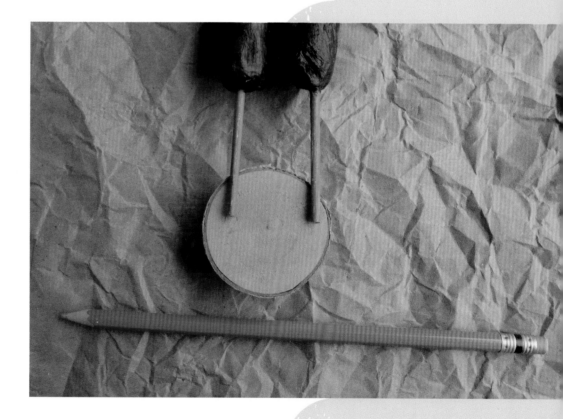

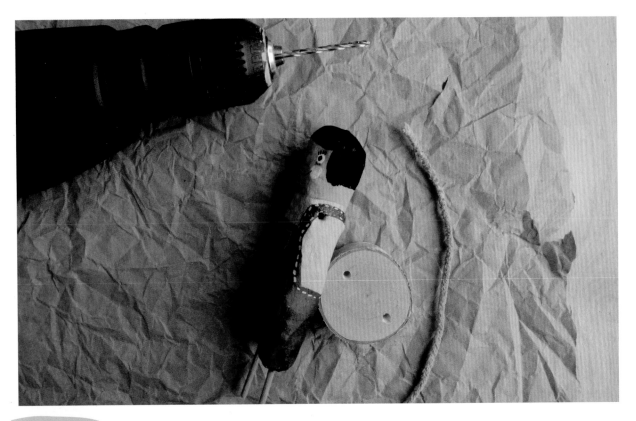

STEP 8

Use a drill bit that will accommodate dowel legs to drill holes in the stand. Then drill a hole at shoulder height through the entire body of the figure.

STEP 9

Stamp or write encouraging messages on the paper.

STEP 10

Cut the message into the shape of a flag. Fold the paper around a piece of wire and glue it in place. Use a binder clip to hold the paper and wire together until the glue dries.

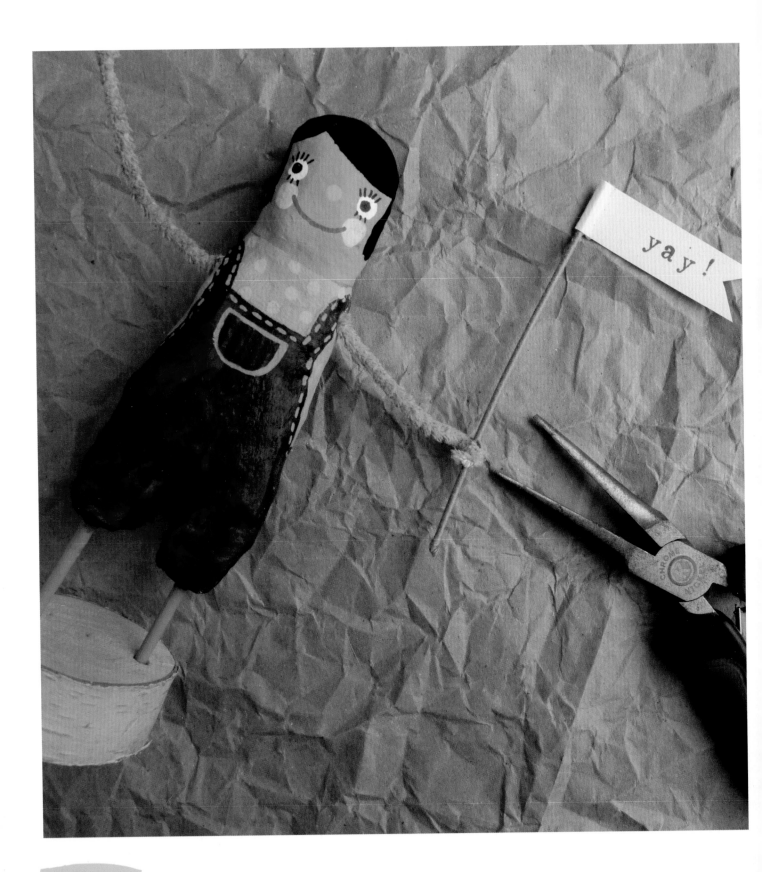

STEP 11

Thread the pipe cleaner arms through the hole you drilled at shoulder height; then wrap the pipe cleaner around the wire flagpole and squeeze with pliers to secure. Arrange the figure's other arm any way you like.

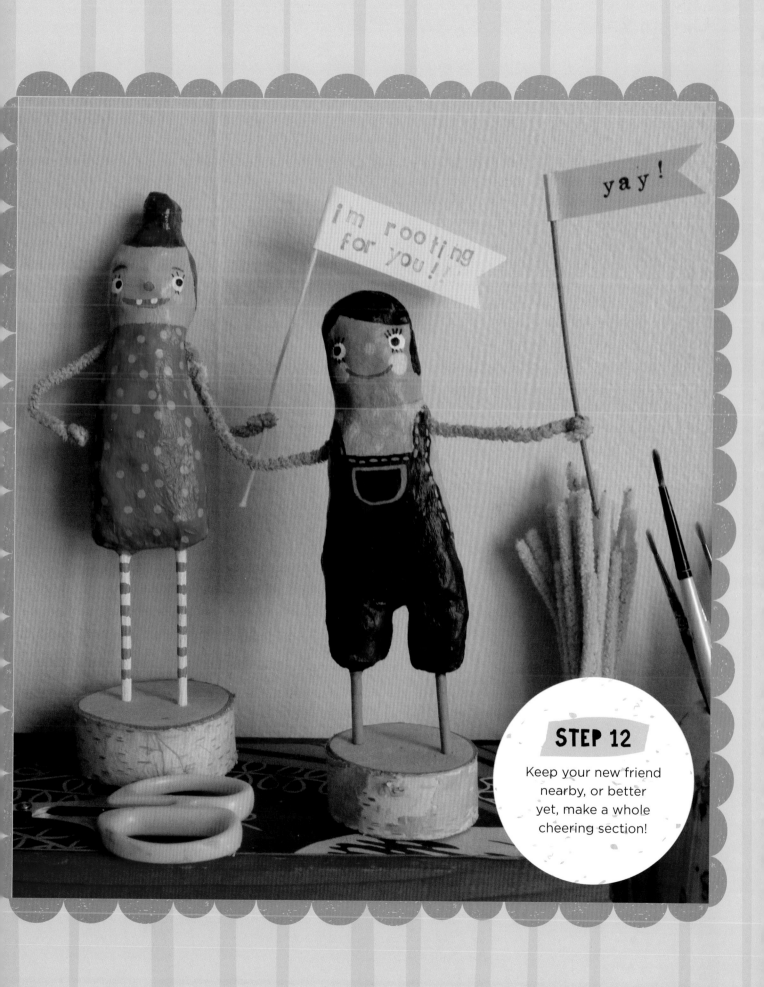

i'm rooting for you!!

yay!

STEP 12

Keep your new friend nearby, or better yet, make a whole cheering section!

Pins

Papier-mâché pins are quick and simple to make. Simple shapes are best—think animals, houses, hearts, ovals, and so on. Create a whole batch and go wild decorating them. Get out all that glitter, collage paper, and even googly eyes! Pins are fun to wear and they make great gifts!

TOOLS & MATERIALS

- Corrugated cardboard
- Craft knife
- Masking tape
- Paste
- Torn paper (any kind)

- Sandpaper
- Gesso
- Paint, collage paper, sequins, glitter, pom-poms, googly eyes, and so on

- Sealer
- Felt
- Hot-glue gun
- Pin backs or safety pins

STEP 1

Sketch the shapes of your pins onto cardboard; then cut them out with a sharp craft knife.

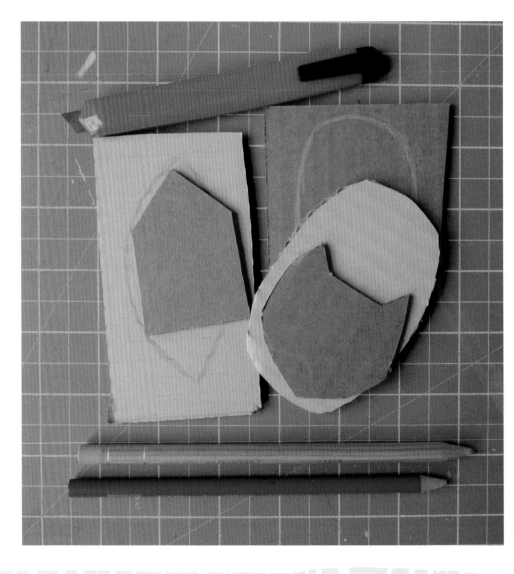

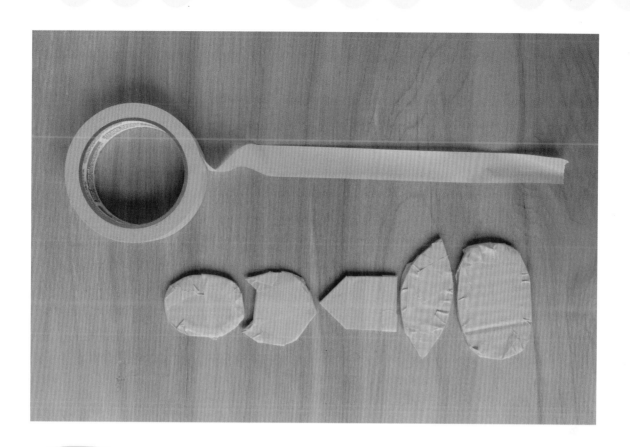

STEP 2

Cover the shapes, including the edges, with masking tape.

STEP 3

Gather paste and torn paper, and add at least one layer of papier-mâché to each pin.
Let dry completely.

STEP 4

Lightly sand the pins to remove any sharp bits of paper, and wipe away the dust. Apply a thin coat of gesso on all sides, and let it dry.

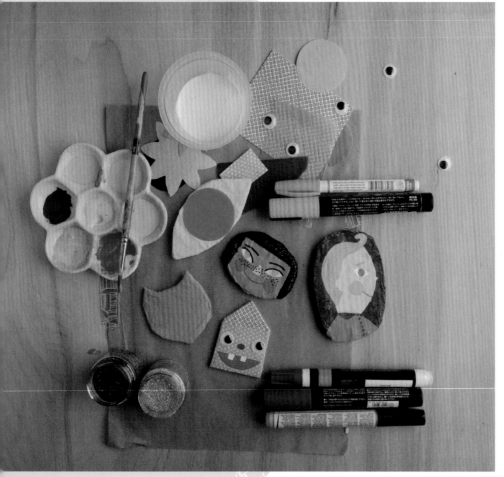

STEP 5

Decorate! Think of these pins as little canvases. Paint, collage, pencil, glitter, googly eyes—use whatever you've got! Once the pins are decorated, apply the sealer of your choice and let it dry.

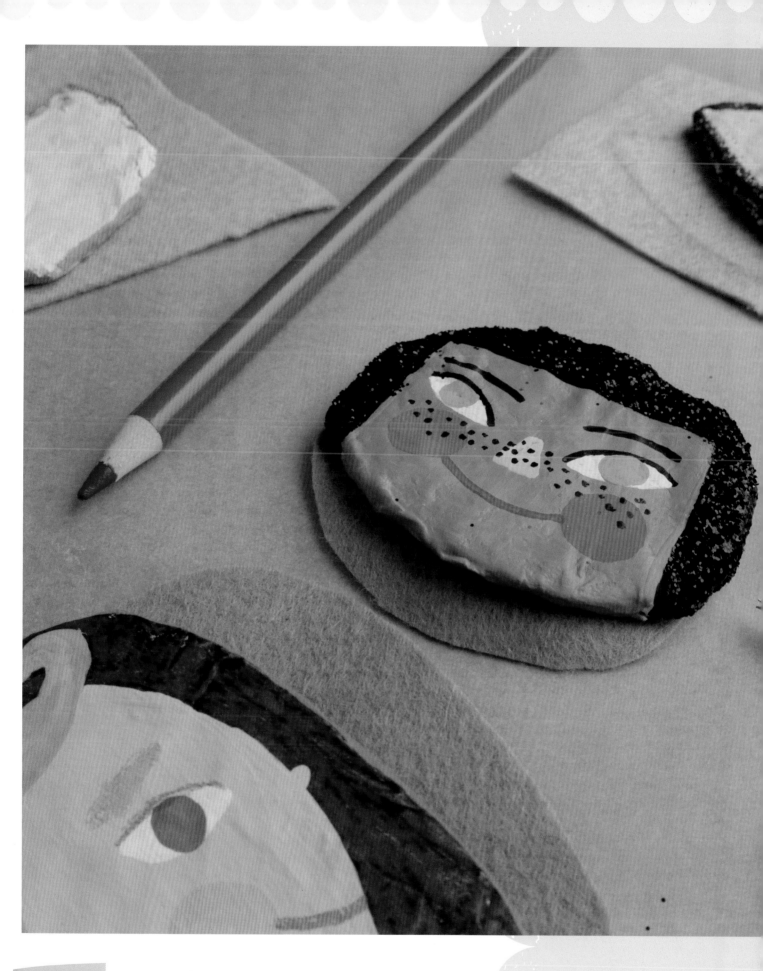

STEP 6

Cut a piece of felt to go on the back of each pin.

STEP 7

Use a hot-glue gun to attach a pin back or safety pin to each piece of felt.

STEP 8

Cut a piece of felt big enough to cover each pin back, glue it down, and glue the whole thing to the back of each papier-mâché pin.

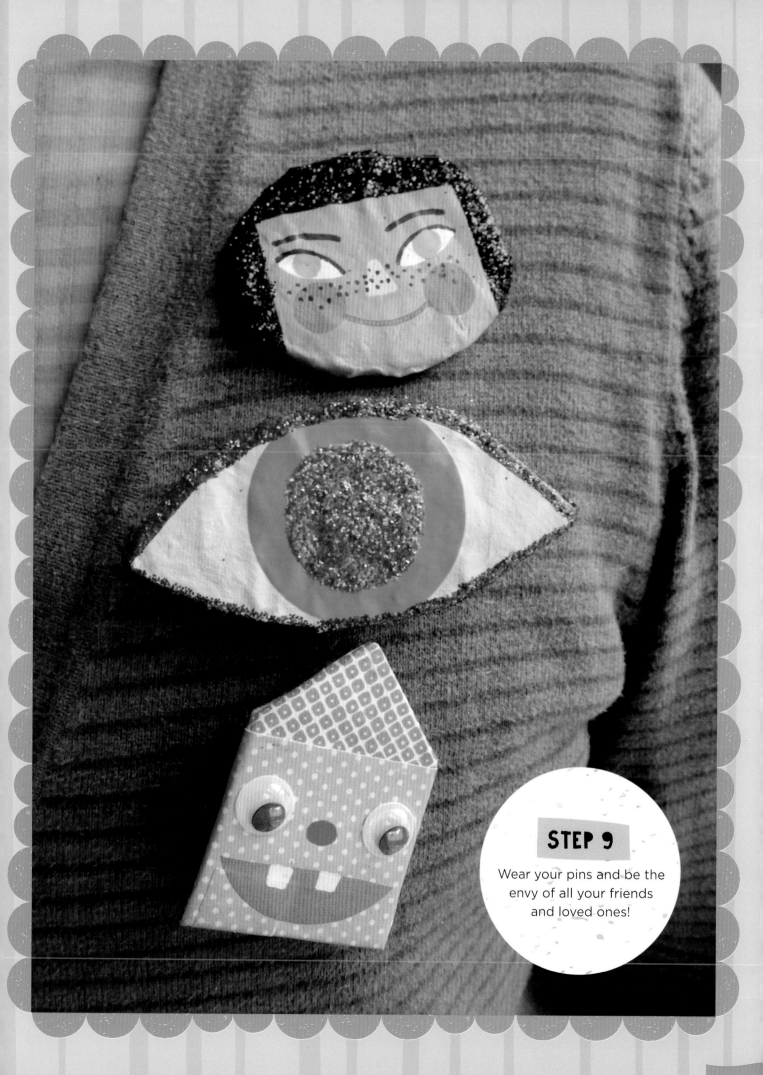

STEP 9

Wear your pins and be the envy of all your friends and loved ones!

Bangle Bracelets

If you've been doing all of the projects in this book, you will find yourself with a few empty tape rolls—but don't recycle them yet! There's a fun way to repurpose them into something cute and wearable.

These bangle bracelets are one of the simplest projects in this book. They feature a tie so that you can adjust the size and are the perfect way to use up leftover bits of fabric or ribbon. Make an armful of these to match every outfit in your closet, and have fun!

TOOLS & MATERIALS

- Scissors
- Empty masking tape rolls
- Masking tape
- Paste
- Shop towels
- Sandpaper
- Gesso
- Paint
- Sealer
- Ribbon, leather cord, or scraps of fabric to tie the bracelets

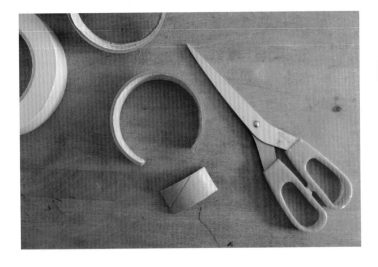

STEP 1

Using strong scissors, cut about 2 inches from each empty tape roll.

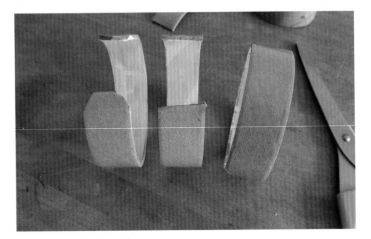

STEP 2

Leave the cut edges straight or carefully round off the corner edges. Another option is not to cut the roll at all to create a more traditional bangle bracelet.

STEP 3

Using very pointy scissors, make a hole in each end of the tape roll. Bore out the hole until it's the right size, as shown. Trim the fuzzy bits of cardboard.

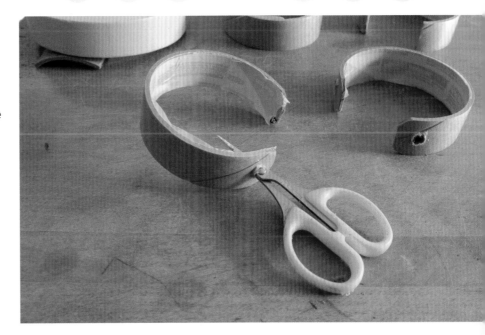

STEP 4

Cover the entire roll with tape, including the holes you made.

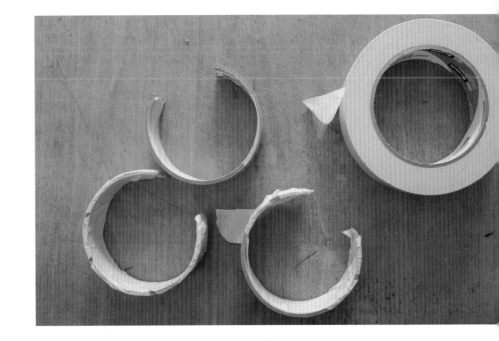

STEP 5

Gather paste and strips of shop towels; then papier-mâché the bangles, wrapping at least two layers of strips around the tape rolls. You want them to be strong but flexible! Don't worry about the holes you made in step 3; you'll uncover them later.

Let the bangles dry in the oven or in front of a fan.

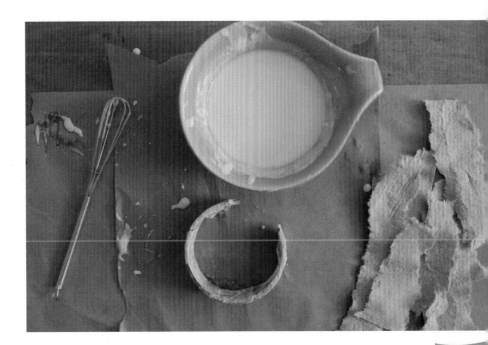

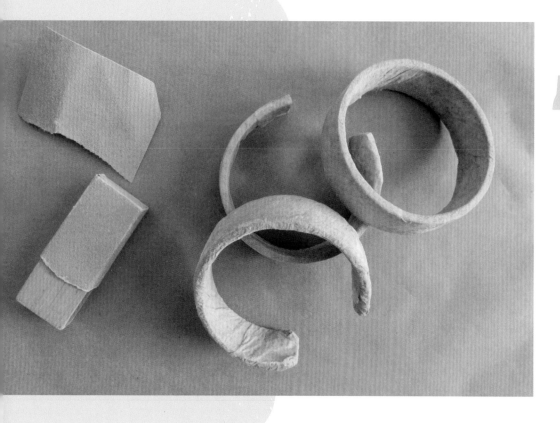

STEP 6

Sand the bangles.

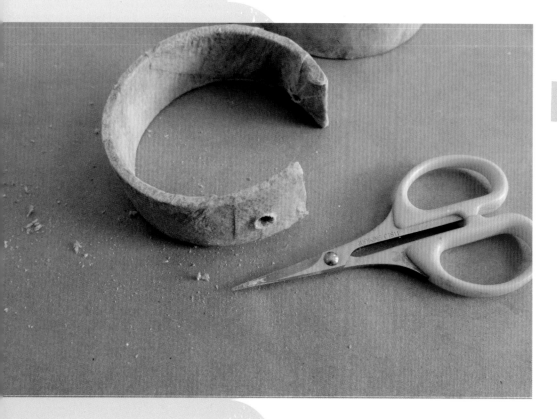

STEP 7

Using your sharp scissors, probe the areas where you poked the holes, and then bore them out again, gently, until you break through the papier-mâché. Trim off any bits of paper.

STEP 8

Apply gesso all over and let dry.

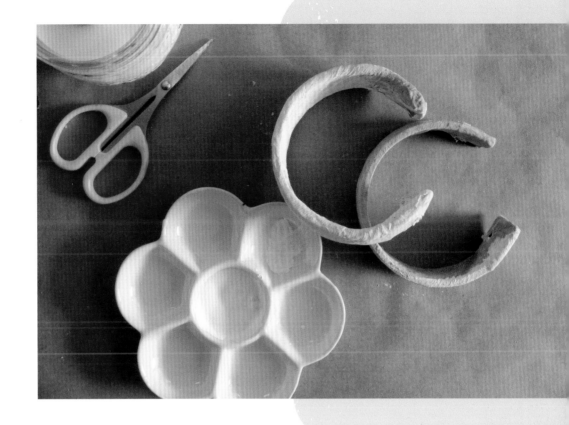

STEP 9

Add paint! I like simple designs like the ones shown here, but you may love to add lots of detail. You can decorate your bracelets any way you like!

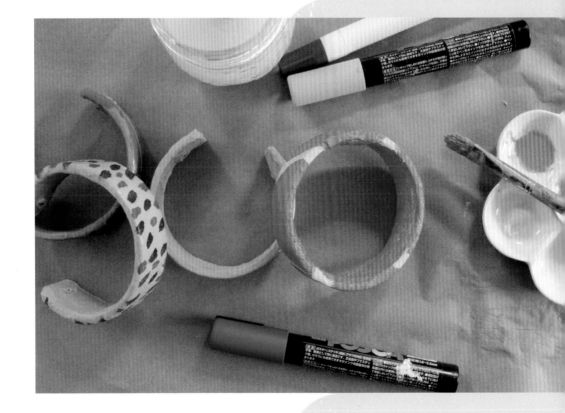

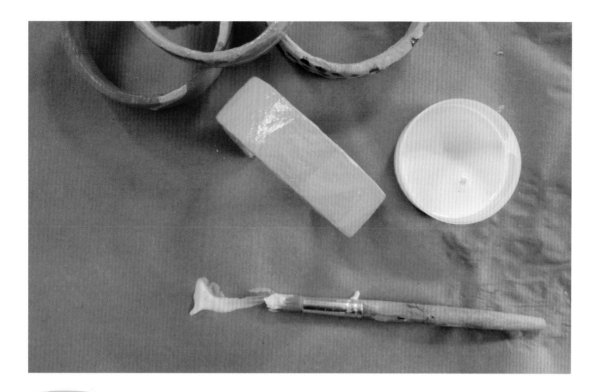

STEP 10

Seal. Go super glossy if you like shine, or use a satin or even a dramatic matte finish. Make sure to use at least two coats of sealer to help protect your bangles as you wear them.

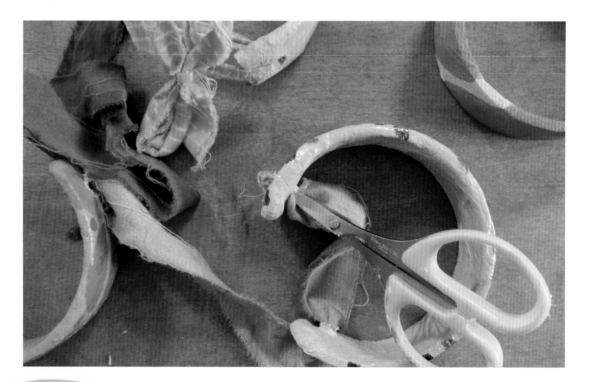

STEP 11

Using your choice of fabric, ribbon, or cord, cut 8-inch strips. You can trim down as needed later.

String the fabric or ribbon through the holes in the bangles. You may need to use scissors to help push it through.

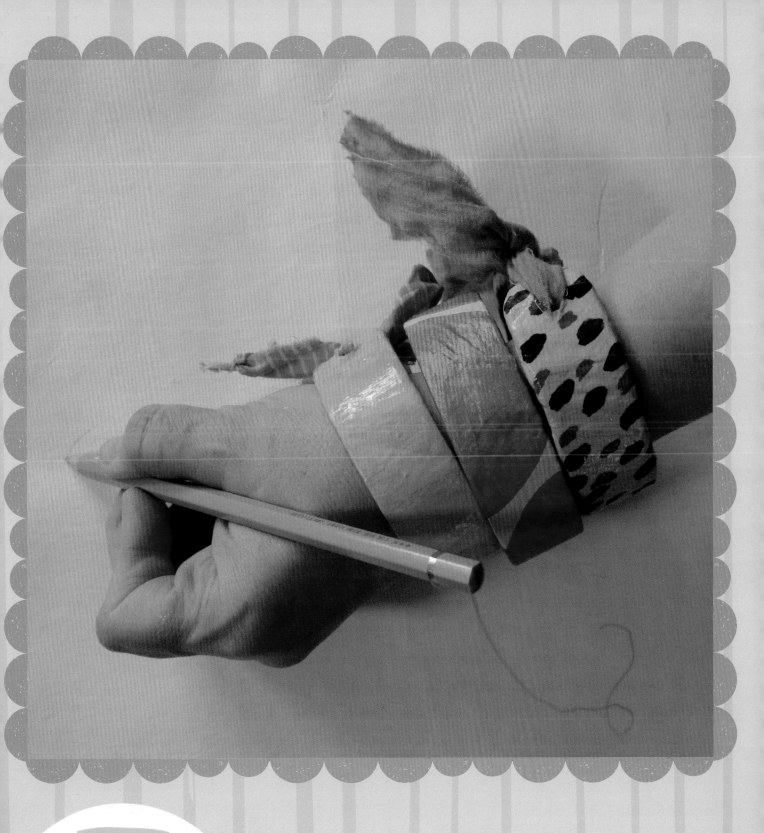

STEP 12

Tie the fabric or ribbon, either in a bow or a nice knot. You can pull the tie to make the bracelet a little tighter; papier-mâché has a little give. Just don't pull it too tight!

Now stack your bracelets and wear them all!

Variations

- Instead of cutting the tape roll, make it a more traditional bangle. You can add extra layers of papier-mâché to thicken the bracelet if it doesn't fit.
- Use a wider or thinner tape roll for variety.

Crown

Whether they're for special occasions or costumes, crowns are magical and fun for anyone to wear. Make a crown for someone special in your life—or for yourself!

This project can be as simple or as complicated as you like. If you want something majestic and minimal, paint your crown with metallic paint. If you want to go full-on fun, paint it with many colors or add glitter, glue, or collage. Either way, you'll end up with a custom headpiece that broadcasts your ruling style to all of your subjects...I mean, friends.

TOOLS & MATERIALS

- Craft knife or scissors
- Corrugated cardboard
- Ruler
- Paper

- Paste
- Parchment or wax paper
- Gesso
- Paint and other decorative items

- Optional: sealer

STEP 1

Cut a length of corrugated cardboard, as shown in the photo. The strip must be long enough to fit around your head comfortably. Don't make it overly snug, as adding papier-mâché will thicken the strip. You should be able to fit at least one finger comfortably between the crown and your head. If it's too loose after you papier-mâché it, I'll show you how to make it fit just right. Cut the length so that the short edges butt up against each other, without overlapping.

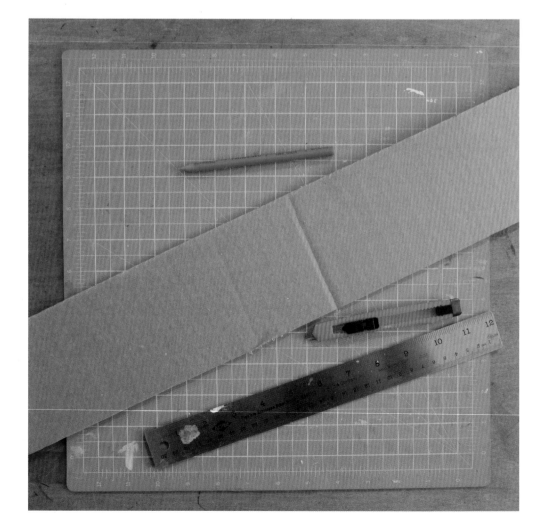

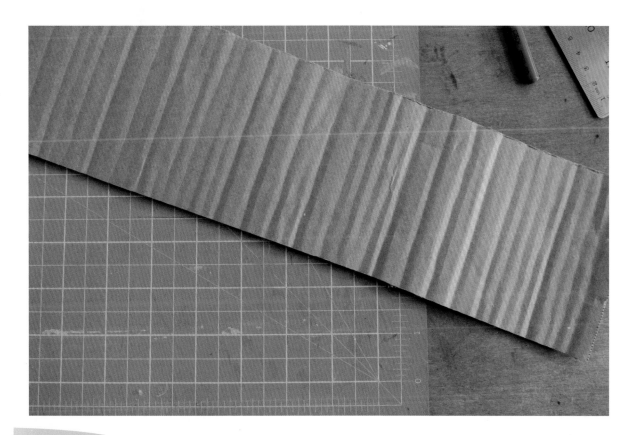

STEP 2

Roll your cardboard strip back and forth a few times on both sides to make it flexible.

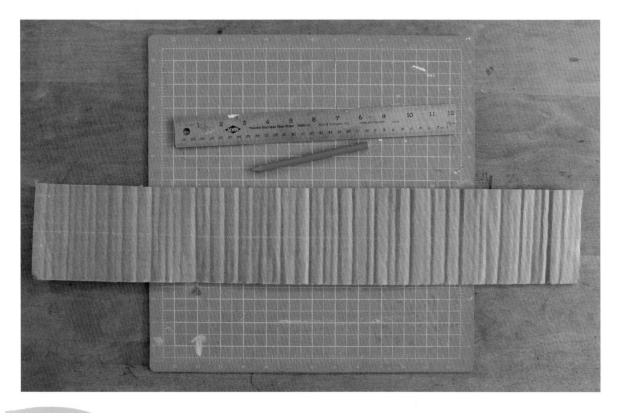

STEP 3

Divide your crown in half lengthwise. I've drawn a line through the middle, dividing it into two halves of 2 inches wide each. Now my band measures 24 inches long and 4 inches deep.

STEP 4

Mark every 3 inches along the strip, and draw lines across the strip at each mark.

STEP 5

Now mark 1½ inches between each 3-inch section at the top edge of the strip.

STEP 6

Connect the lines in each side section to meet in the middle and form the points of the crown.

STEP 7

Use a craft knife and ruler or a strong pair of scissors to cut away the triangles you don't need.

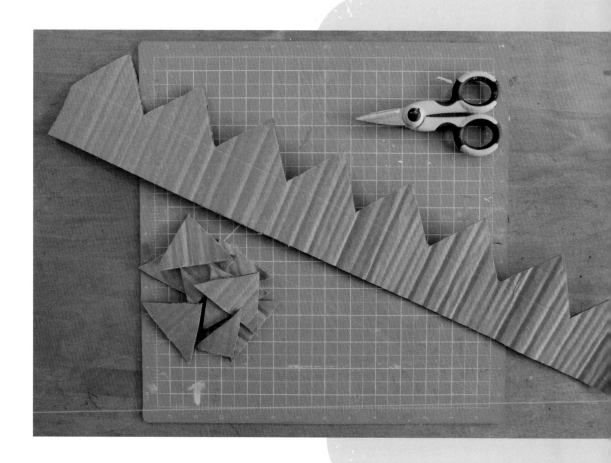

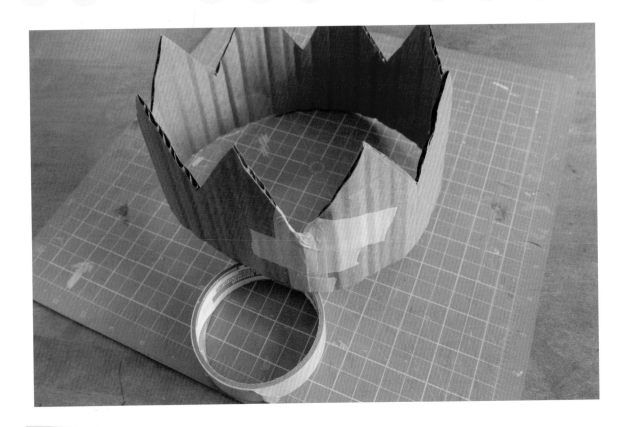

STEP 8

Place the ends of the crown snugly together, without overlapping, and tape
well, inside and out.

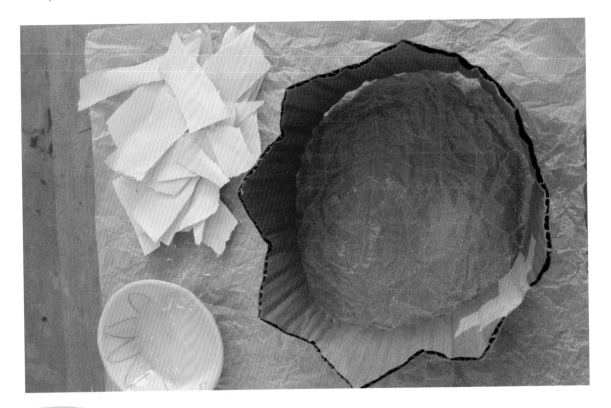

STEP 9

Now you're ready to papier-mâché the inside and outside of the crown. Prepare your
paper (any kind) and your paste (any kind). Wrap strips around the points as well, and
make sure the bottom edge is finished with papier-mâché. I've found that one layer is
sufficient, but you can add as many layers as you'd like.

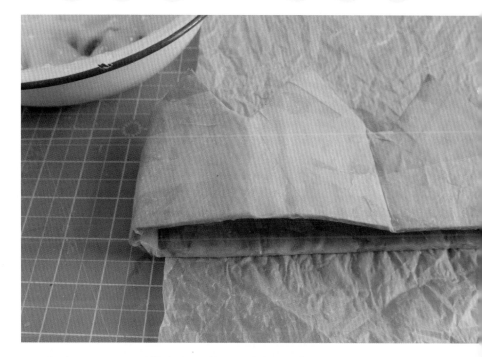

Tip

As you papier-mâché the crown, it will likely sag and flatten out of its nice circular shape. That's OK; you will reshape it before it dries.

STEP 10

To dry the crown, place it on parchment or wax paper, and shape it back into a circle as well as you can. Now you can let it air dry or dry in the oven for 30 minutes.

Ensure that the crown is completely dry, and then sand it if you like.

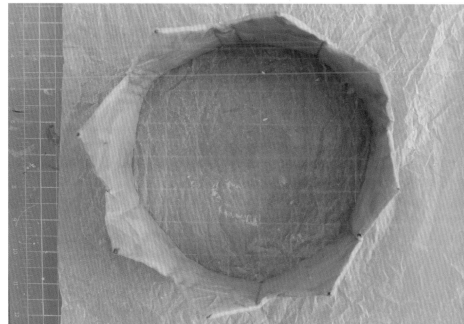

STEP 11

Add gesso!

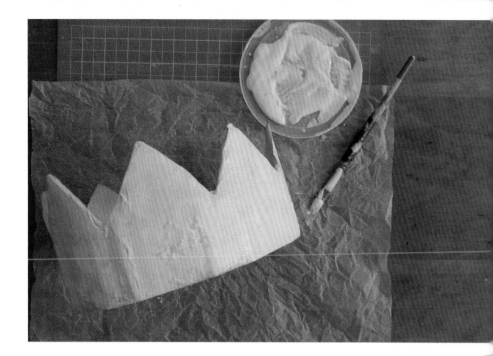

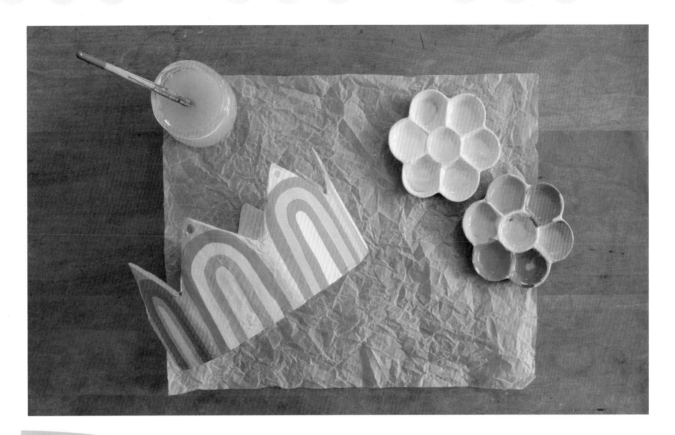

STEP 12

Add paint! Is your crown simple and regal, or do you want to break out the glitter? I've added a plethora of rainbows to my crown, but you could paint a name on it or encrust it with rhinestones or bottle caps.

Let the paint dry and seal the crown if necessary.

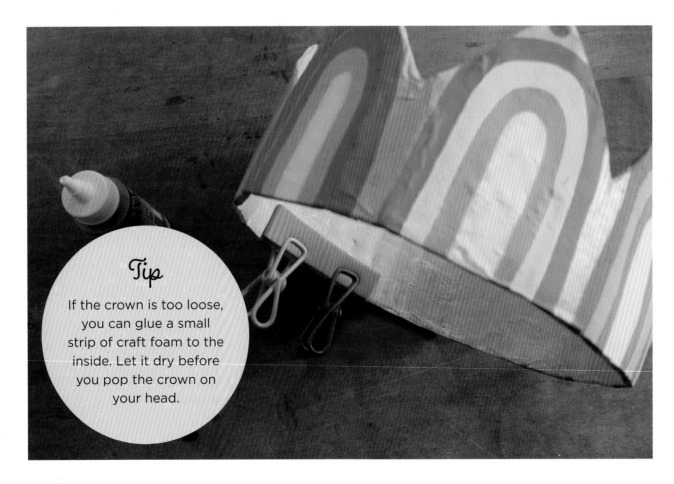

Tip

If the crown is too loose, you can glue a small strip of craft foam to the inside. Let it dry before you pop the crown on your head.

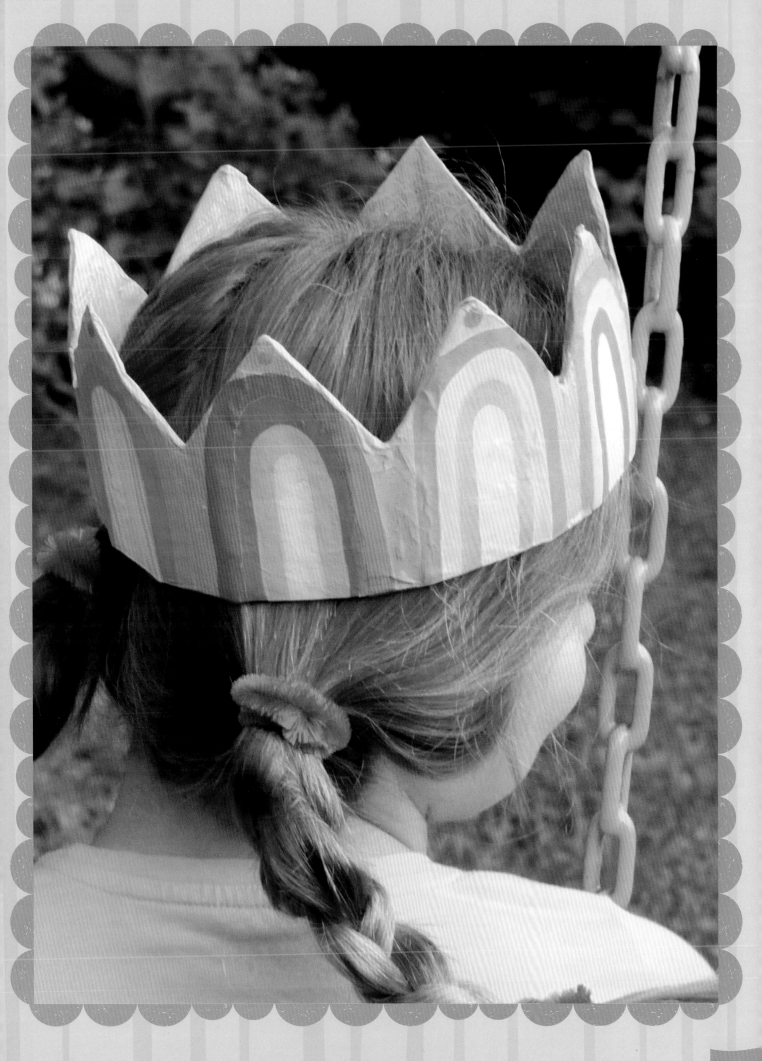

Chunky Beaded Necklace

If you like dramatic jewelry, this project is for you. Simple shapes and layered, textured paint make this necklace super fun to create and even better to wear.

TOOLS & MATERIALS

- Aluminum foil
- Masking tape
- Dowels
- Paste
- Paper
- Sandpaper and sanding sponge
- Paper towel
- Gesso
- Paint and paint pens
- Sealer
- Leather cord, ribbon, or strip of fabric

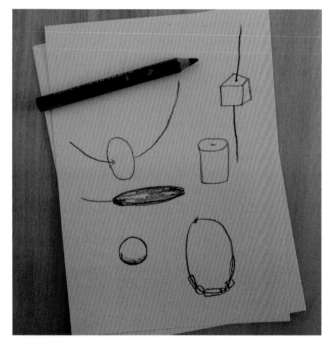

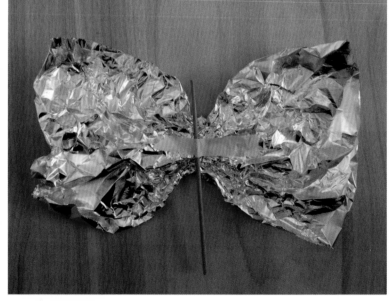

STEP 1

Begin by doodling a few shapes for your beads. Plan to make a handful of beads so that you have options and can play with their configuration when you string them.

STEP 2

Easy to shape, strong, and lightweight for wearing, aluminum foil will form the base of these beads. Tear a piece of foil and crumple it in the middle to divide it in half. Very lightly tape a dowel to the center of the foil, ensuring that the dowel hangs off both sides of the foil. Repeat for each bead.

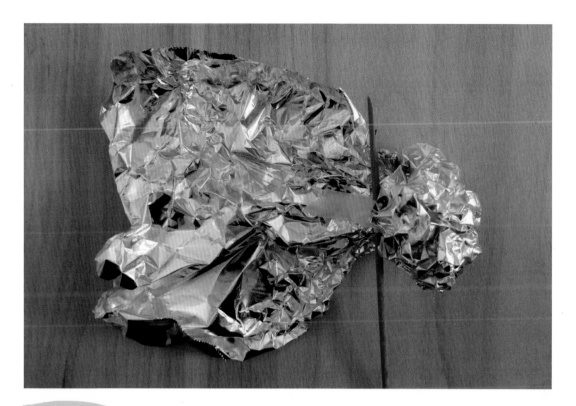

Squish and pinch the foil into the bead shapes you want, working with half of each bead at a time. You can roll the beads on a hard surface to compress and shape the foil. Make sure to keep the dowels in the centers of the beads.

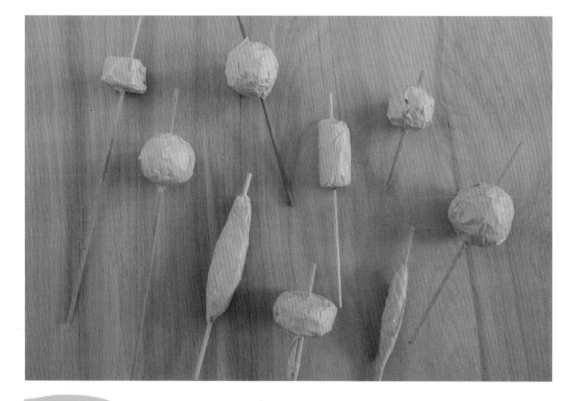

STEP 4

Place masking tape around each bead, ensuring that a bit of tape is stuck to each dowel as well so that the beads don't move around as you work on them.

STEP 5

Once you're happy with your beads, it's time to papier-mâché them! Make your paste and tear up some paper. Use small pieces of paper so that they adhere to the beads. Go slow and really rub down the paper as you place at least two layers on each bead. Cover the whole area of each bead so that the foil doesn't show. Let the beads dry.

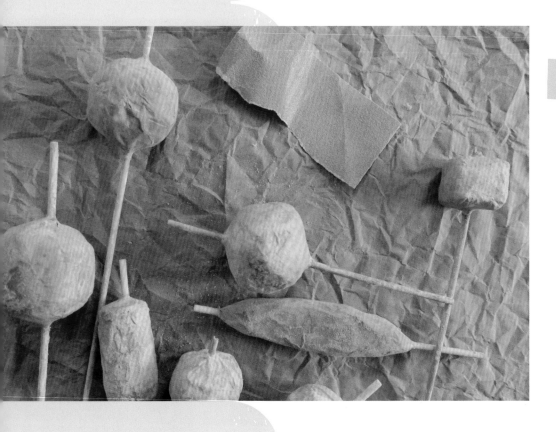

STEP 6

Sand off any sharp bits or lumps that need smoothing; then wipe off the dust with a paper towel.

STEP 7

Gesso the beads and let them dry. They will dry best if standing. You can stick the dowels in a piece of Styrofoam, set them in a jar if they're long enough, or prop them up so that the bead doesn't rest on the table.

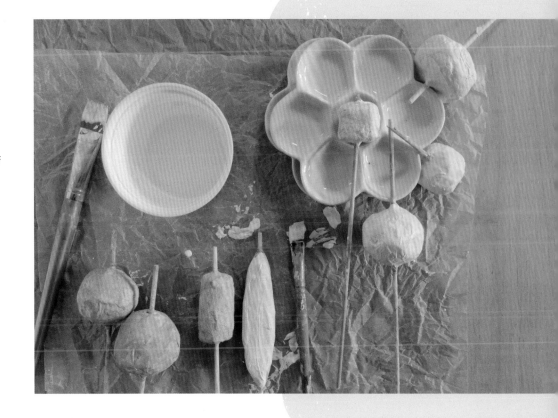

STEP 8

Add paint! These beads are big and bold, so choose a pleasing color scheme. Let's add a bit of texture to the beads too.

Begin by underpainting each bead; then let this layer dry completely. I've used shades of green and then added my final color scheme of light pinks, blues, ivory, and white. Let this layer dry thoroughly as well.

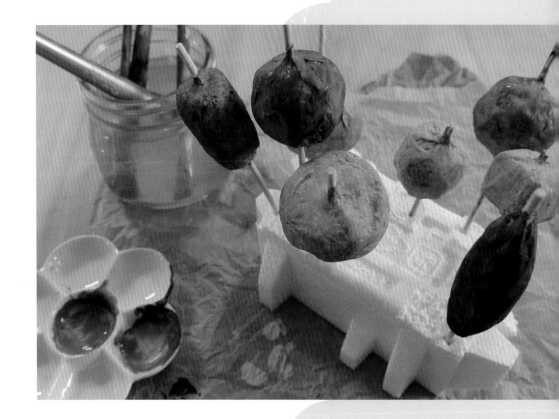

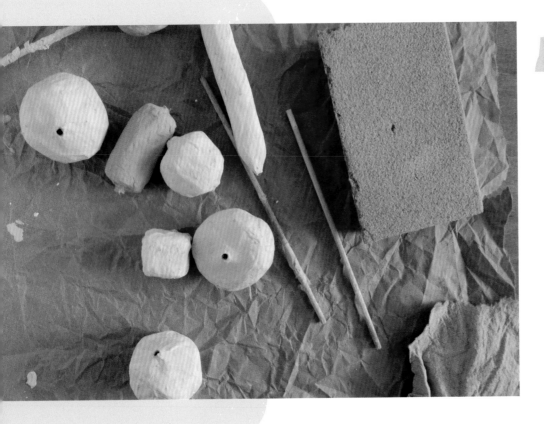

STEP 9

Remove the dowels to prepare for the next step. Hold a bead gently but firmly in one hand and use the other hand to twist each dowel to loosen the bead.

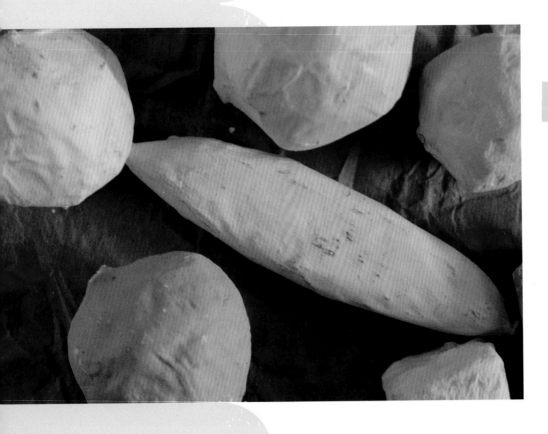

STEP 10

This step is optional, but weathering the paint will give the beads added interest and depth. Take your sanding sponge and, with a light touch, scuff the beads so that elements of the underpainting are revealed. You can choose to weather them very lightly or take a lot of the outer paint layer off. If you don't like how it looks, just repaint and let dry! Wipe off the scuffed paint with soft paper towel.

STEP 11

If you want to add patterns to your beads, now is the time. You can use paint pens or a fine paintbrush with paint. Take your time with small details. Dots and stripes make excellent choices, but you can experiment with anything!

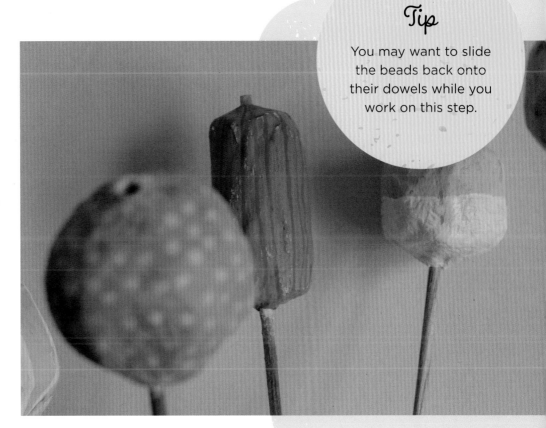

Tip

You may want to slide the beads back onto their dowels while you work on this step.

STEP 12

Seal those baubles! Extra layers of sealer are important here to keep your necklace durable and the paint from chipping with wear. Let each layer dry before adding another one—three layers are ideal!

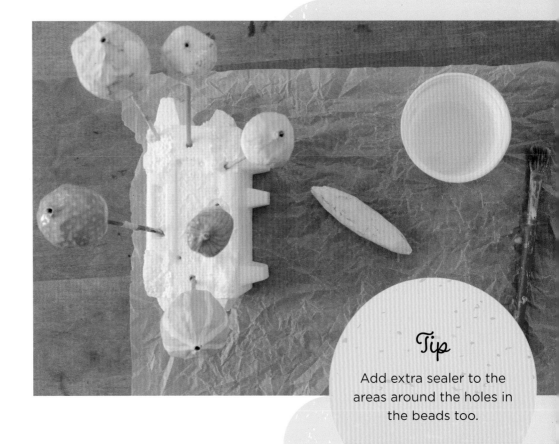

Tip

Add extra sealer to the areas around the holes in the beads too.

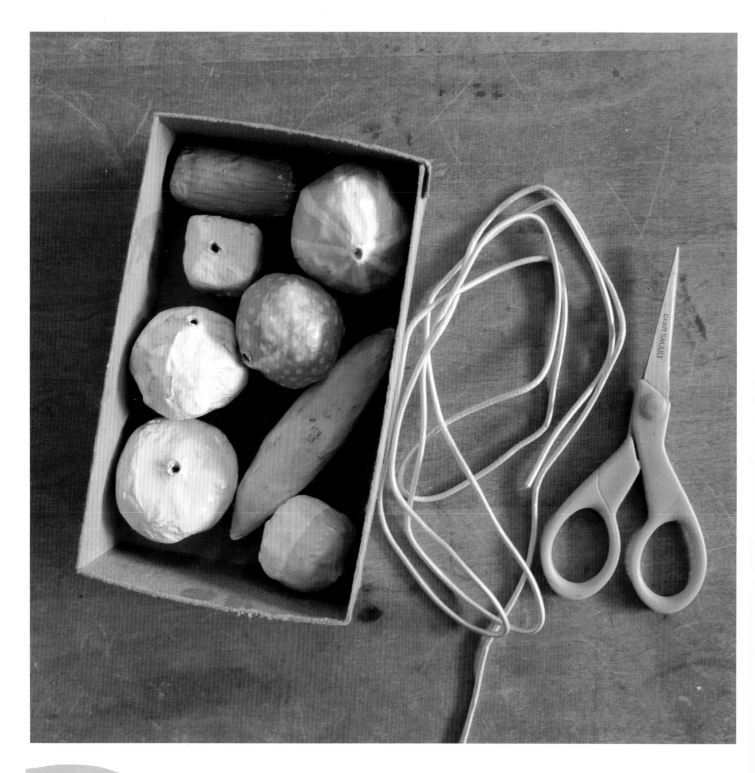

STEP 13

Play around with the arrangement of the beads to decide on their configuration. Then cut a piece of leather cord, fabric, or ribbon long enough for stringing the beads, knotting, and fitting over your head.

Now, string the beads. If you use leather cord, you can slide it through the holes in the beads, but you will need a large needle with a big eye if you use fabric or ribbon.

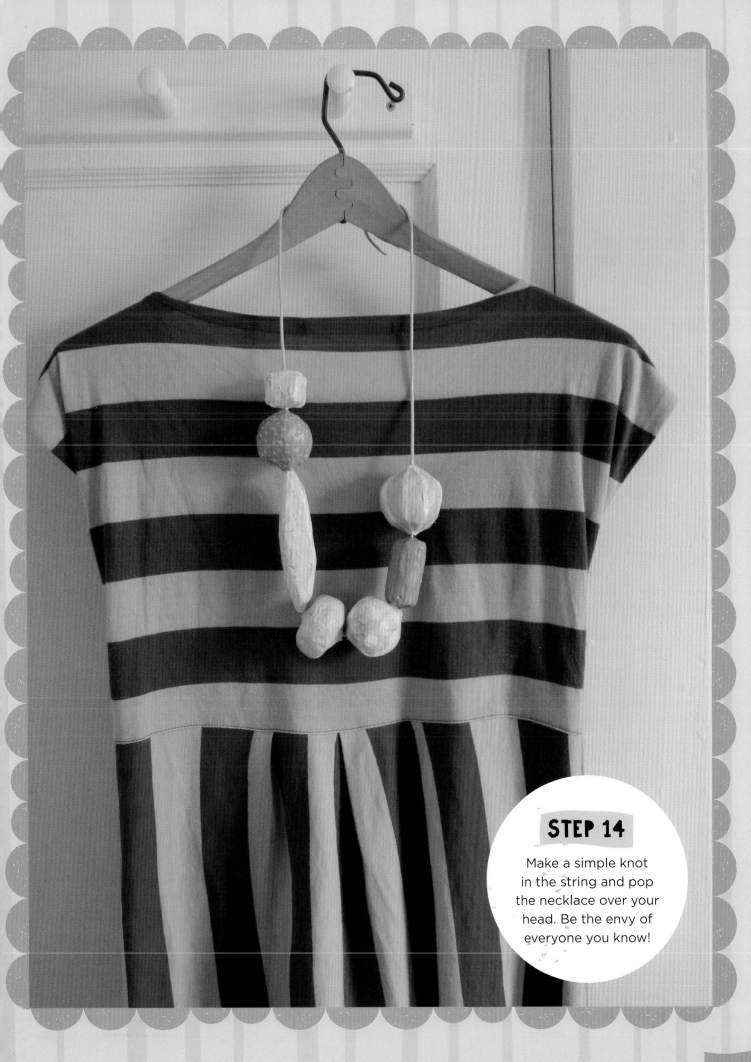

127

About the Artist

Sarah Hand is a papier-mâche artist, an illustrator, and an art teacher. A puppet show she created when she was 30 inspired her to pursue the art of papier-mâche in earnest. This messy, fun medium was an undiscovered well of inspiration for Sarah. Creating creatures, dolls, and puppets led her to teach the magic of papier-mâche to children and adults alike.

Sarah has taught for more than 15 years at the Virginia Museum of Fine Arts, the Visual Arts Center of Richmond, Studio Two Three, art retreats, and online. Her work has been featured in Somerset Studio magazine, and she has had many solo art exhibits.

When she's not elbows deep in paste and paper, you can find Sarah painting, drawing, and dreaming up stories and images for picture books.

Sarah lives and creates in Richmond, Virginia, with her husband, Phil, and their three-legged cat, Roger.

DEDICATION

For Phil, for believing in me forever.

And for my mom, who has always encouraged my creativity.

ALSO AVAILABLE FROM WALTER FOSTER PUBLISHING

Art Makers: Polymer Clay for Beginners
978-1-63322-632-6

The Grown-Up's Guide to Crafting with Kids
978-1-63322-860-3

The Grown-Up's Guide to Painting with Kids
978-1-63322-854-2

Inspiring | Educating | Creating | Entertaining

Visit www.QuartoKnows.com